LOST SHEFFIELD
IN COLOUR

IAN D. ROTHERHAM

AMBERLEY

ABOUT THE AUTHOR

Ian Rotherham is Professor of Environmental Geography and a Reader in Tourism & Environmental Change at Sheffield Hallam University. He is an environmental historian and a worldwide authority on ecology, landscape history and on tourism and leisure. Born in Sheffield, Ian established and directed Sheffield City Council's Ecology Service within the City Museums Department, writes for the *Sheffield Star* and the *Yorkshire Post* newspapers, and has a regular phone-in on BBC Radio Sheffield. He is a regional ambassador for Sheffield and the region and has written, edited and published over 400 papers, articles, books and book chapters. He lectures widely to local groups and works closely with conservation organisations and agencies.

First published 2013

Amberley Publishing
The Hill, Stroud, Gloucestershire, GL5 4EP
www.amberley-books.com

ISBN 978 1 4456 1771 8

British Library Cataloguing in Publication Data.
A catalogue record for this book is available from the British Library.

Typesetting by Amberley Publishing.
Printed in Great Britain.

CONTENTS

Introduction: Sheffield, a Remarkable City | 4

1 The Town Centre | 8

2 Industry and Commerce | 39

3 Around and About Sheffield Centre | 54

4 A City of Rivers | 67

5 People and Places | 74

6 Parks and Gardens | 82

7 Education, Health and the Arts | 99

8 Transport In and Around the City | 109

9 Sports, Theatre and Activities | 120

Acknowledgements and Credits | 127

Bibliography and Suggested Reading | 128

INTRODUCTION: SHEFFIELD, A REMARKABLE CITY

Sheffield and its hinterland of South Yorkshire are located to the north of the English Midlands. A major river system, the Don to the Humber, flows to the east and out to the North Sea, and the high ground of the Peak District National Park is to the west. Until the 1600s or 1700s, this was largely an ancient landscape of wetlands, rivers, moors, commons, woods and forests, and deer parks and chases. There was some localised industry linked to early metalworking, coppice woodland management, and especially to waterpower from the rivers. Urban development was restricted to small riverside settlements of a few thousand people in Sheffield, Rotherham, Chesterfield, Barnsley and Doncaster, with some settlements originating perhaps 1,500 years ago in Roman times. There has followed a long-term transformation of the region and its main city, Sheffield. Through industrialisation and urbanisation, over a period of around 500 years, Sheffield and South Yorkshire grew from primarily rural to massively industrial, and then in the late twentieth century to post-industrial. The recent drivers of change have included post-industrial urban renewal with the catalysts of sport, leisure, tourism, education and environment. These have combined to transform both places and people.

Sheffield is the fourth-largest city in England, and despite its history of steel, iron, coal and manufacturing, boasts more ancient woodlands than any other industrial centre in Western Europe. It is a remarkable place with unique heritage and deep-seated contradictions in its character, its people and its heritage. Described by George Orwell in *The Road to Wigan Pier* as the dirtiest, smelliest, ugliest city in the world, its name became a byword for clean air.

... But even Wigan is beautiful compared with Sheffield. Sheffield, I suppose, could justly claim to be called the ugliest town in the Old World: its inhabitants, who want it to be pre-eminent in everything, very likely do make that claim for it ... And the stench! If at rare moments you stop smelling sulphur it is because you have begun smelling gas. Even the shallow river that runs through the town is usually bright yellow with some chemical or other. Once, I halted in the street and counted the factory chimneys I could see; there were thirty-

three of them, but there would have been far more if the air had not been obscured by smoke.

George Orwell, 1937

Orwell goes on to point out that while there is no inherent reason why industry should be dirty and ugly, Northerners have become used to and tolerant of these conditions. Today, as Melvyn Jones points out, Sheffield is the most wooded industrial city in Western Europe. Poet Laureate John Betjeman praised the western suburbs of Sheffield as some of the greenest and prettiest in England. This is a part of the mixed-up personality of Sheffield. The city, which led the Industrial Revolution, also gave rise to campaigns for access to the countryside and ultimately both National Parks and Green Belts. Sheffield was where the Industrial Revolution began in earnest and became the biggest steel manufacturing centre in Europe. The city's high-quality steels and fine cutlery were, and still are, famous across the world. Today there are two large universities and Meadowhall, the biggest shopping centre in Europe, yet there is so much more to Sheffield's history and heritage. As a border town between North and South from the Romans onwards, this region was significant in national politics and power. The great Saxon kingdom of Northumbria extended from here north to Edinburgh, and to the south was Mercia, the powerhouse of a united English kingdom. The River Don divided the North from the South, a division reinforced by great wetlands and wooded areas of higher ground. To this day, Sheffield is a border town; the south of the North rather than the north of the South, and the lowland edge of the uplands, not vice versa.

At the heart of this great city are its five rivers, the Rivelin, the Loxley, the Porter, the Sheaf, and of course the Don. This last is the biggest and cuts a swathe through the very heart of the town. The rivers, the city, the people, are all intertwined, and Sheffield's poet the Corn Law Rhymer wrote eloquently of the beauties of the Lower Don Valley:

Don, like a weltering worm, lies blue below,
And Wincobank, before me, rising green,
Calls from the South the silvery Rother slow,
And smile on moors beyond, and meads between,
Unrivall'd landscape

Ebenezer Elliot, 1836

It is hard to imagine such a landscape when viewed from Wincobank Hill today. Yet this flatland, between Sheffield centre where the main river crossing was at Lady's Bridge, and where the M1 motorway now runs, was once a great wetland. As quoted by the great antiquarian Joseph Hunter in 1819, in 1546, the ancient chapel at Attercliffe was still in use and the curate of Rotherham, at that time the major town and main ecclesiastical centre, would come to his flock when it was too wet for them to come to him 'to mynistre to the seke people, as when the waters of the Rothere and Downe [Don] are so urgent that the curate of Rotherham cannot to them repayre, nor the inhabitants unto hym nether on horseback or bote'. Indeed, along the River Don and the nearby Rother, until the 1950s, many local people had boats in case the river burst its banks; all part of living near the water. The 2007 floods were a salutary reminder that human superiority over nature may well be a transient phenomenon.

With its dramatic growth in population and its remarkable industrial success, Sheffield became famous for other, often less desirable things too. Air pollution took its toll in bronchial diseases often exacerbated by exposure to metallic wastes and dusts inhaled in the cramped, confined spaces of urban industrial sweatshops. By the 1970s, Sheffield University Medical School was the place to study if you wanted to gain experience

in nasty industrial diseases from metalworking or mining, or in serious industrial accidents. Along with air pollution, the town's water supplies were also a source of disease and death as cholera and typhoid took their toll. In the mid-1800s, the average life expectancy in inner-city Sheffield was around twenty-four years. The brand of 'Made in Sheffield' came at a cost in human life and suffering.

Sheffield and its region was a powerhouse for England, for the Empire, and for the world beyond. As the British Empire spread around the planet, materials manufactured and produced in the area spread as a global brand. This reached a peak in the mid-twentieth century, as a slow decline began in the aftermath of the Second World War. However, the emerging city was not just an industrial centre; as an economic powerhouse it drew in and grew academics and philosophers, writers and artists, industrialists, inventors and politicians. From the energy of industry grew a powerhouse of social and educational development and reform. Yet this emergence came in the face of a rapid decline in social welfare, in health and in quality of life for the vast majority of people. The other major cost was in the almost total decline in environmental quality, as rivers once rich in salmon and other fish became dead, stinking sewers. By the 1970s, with riverside pastures and meadows destroyed or grossly polluted, the rivers themselves were dead and brimming with raw sewage and detergent foam.

From the 1970s into the 1990s, the city and region entered a rapid and dramatic downturn in its industrial base. Furthermore, while a reorganised specialist steel sector continued to thrive, it now employed relatively small numbers of people. At the start of the 1970s, the industrial Lower Don Valley in Sheffield employed around 70,000 people directly, and many more in related service industries. Most of these people lived in tightly packed communities in and around the valley where they worked. Almost overnight, the jobs and the people disappeared forever.

This was a time of economic decline, of identity crisis for the city and its communities, of unemployment and strikes, of energy shortages and the 'Three-Day Week' of the 1970s, Margaret Thatcher of the 1980s, the North–South divide, and political crisis and unrest. Miners took to the streets in protest and were brutally suppressed by police brought in from London. Coalmines closed, factories closed, land lay derelict and entire communities were out of work. Where large factories remained, they were increasingly vulnerable to takeover by capitalists from elsewhere, outside the city or even outside the UK. When this happened, local people lost what control they might have had in determining their own destinies. This was the city and the time so richly captured in films such as *The Full Monty*, and nearby in Barnsley, *Brassed Off*. There were also major regional issues of competition for investment, jobs and status between Sheffield and Leeds to the north, Nottingham to the south, and Manchester to the west. This remains a deeply divisive issue for people and for politicians. Yet as Orwell notes, Sheffielders expect to be top at everything, even pollution.

In the 1950s, fuelled in part by a realisation and indeed embarrassment of mass deaths due to air pollution by smog from industrial and domestic coal burning, Sheffield pioneered the idea of Clean Air and Smokeless Zones. Combined with laws to protect watercourses from pollution and to control land degradation too, a slow process of urban ecological renewal began. Ironically, the changes were speeded by the closure of many of the factories that had been responsible for the problems. However, Sheffield, once famed as the 'Dirty City in a Golden Frame', began to grow a sense of civic pride as 'The Clean Air City', and by the 1980s, as a 'Green City'. From these beginnings in the 1980s, there developed an interest in the potential for a genuine renewal of the landscape and ecology of the Lower Don Valley, the city's former industrial heartland. Indeed, with little prospect of economic renewal, the derelict and despoiled landscape was considered

a barrier to investment. Furthermore, even without intervention, nature was quickly reclaiming miles of unused former factory sites.

Sheffield has always had a tendency to be parochial and remains so even today. Each valley has its own people, its own societies and even its own dialects. Nowadays, as people move around more the dialects change, but they still have local variants. Often described as a collection of villages morphed into a larger town, Sheffield is distinctly different from its neighbours such as Leeds, Nottingham and Manchester. Indeed, today Sheffield remains proudly different and distinctive. The people are famously friendly and nowadays, with the catalysts of the two universities, Sheffield has grown an enviable tradition and reputation and a tourist centre too. Recent city-centre projects have transformed the city's transport network and the European-style street café culture is rich and welcoming for locals and visitors alike.

THE TOWN CENTRE

Old Sheffield is on a low hill overlooking the confluence of the rivers Don and Sheaf. This is the area today, which includes the old legal quarter behind the cathedral and Sheffield's few remaining Georgian streets and squares. On the flatland below is the ancient river crossing at Lady's Bridge, underneath the current structure of which lie the medieval arches. On the north side of the river stood the massive structures of Sheffield Castle, demolished during the English Civil War. The ruins of the substantial towers, gatehouse and ramparts lie under the old Castle Markets. It is hoped that with re-development of the area these vital parts of Sheffield's heritage will once again be revealed.

The Edwardian High Street is shown with both single-decker and double-decker trams and what seem to be delivery carts with barrels, perhaps delivering ale to local hostelries. The streets are thronged with shoppers and others going about their daily business, and for a change, there is a blue sky showing over the city centre. Maybe the wind was from the west and blowing the pollution away to the east.

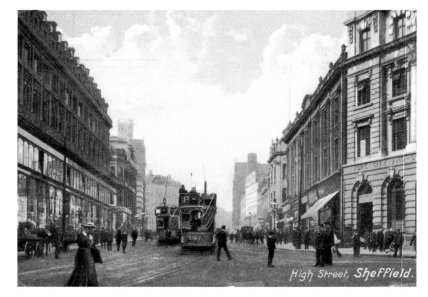

High Street, Sheffield.

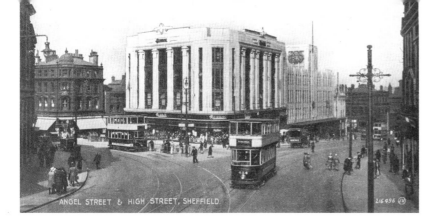

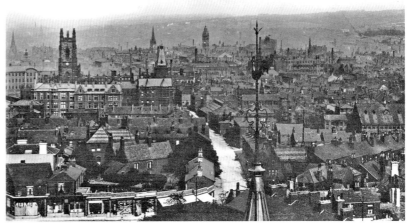

Above left: Angel Street and High Street in Sheffield city centre with shoppers and trams, probably 1930s. This busy scene shows the hustle and bustle of Sheffield centre with trams, vans and motorcars. New and rather grand white buildings contrast with the smoke-stained stone of the older premises.

Above right: This bird's-eye view of the city from Sheffield University in the early 1900s shows the 'new' Town Hall in the distance to give a marker for the town centre. In between are the tightly packed urban developments of West Street and Division Street with the now thoroughly modern Devonshire Green area. St George's church stands out with the Jessop's Hospital and the rows of shops, narrow roads and factory chimneys contrast markedly with the modern scene.

Right: The Brunswick Wesleyan Chapel on The Moor, formerly South Street, is shown in 1905 and was one of many chapels and churches that sprang up across the city. The horse-drawn bus and the horse and cart give a strong sense of the period. Brunswick was part of the East Circuit of Methodist chapels with five regular ministers and forty-seven local preachers. Other chapels were at Wesley College, Norfolk Street, Park, Carver Street, Bridgehouses, and Ebenezer. The Carver Street Chapel could accommodate 2,000 people. Much of the lower Moor area was flattened in the 1940s Blitz.

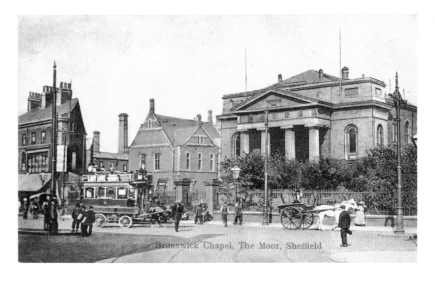

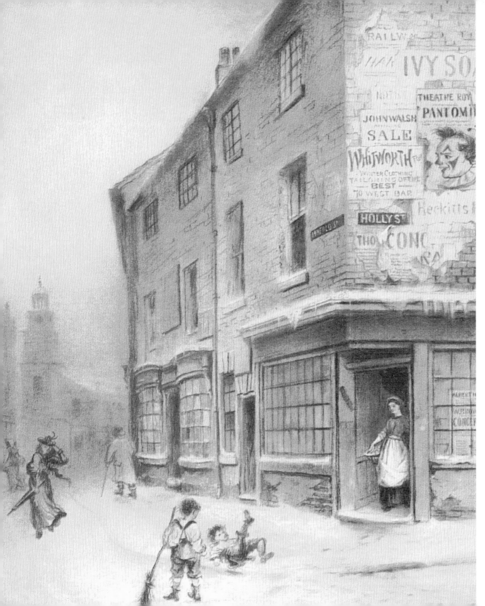

Above: Coles Corner in Fargate was a famous meeting place for Sheffield folk. Here it is pictured around 1880 by Pawson & Brailsford. Confusion arose as the company moved to their new premises at Barker's Pool, opposite the City Hall, but older people still referred to 'Coles Corner'; I know of a few people who stood waiting in vain at the wrong place. Today the main shop is John Lewis, but for locals it will always be Coles. The original business was Cole Brothers' drapers shop, which opened in 1869.

Left: This view of the 'Corner of Pinfold Street and Holly Street', in 1895, was by A. Wilson and shows a snowy street scene with children playing. As well as falling over, they are playing with a beesom, the traditional broom made from a coppice pole and cut birch branches. These were widely used in local industries and would have been produced in the countryside around Sheffield.

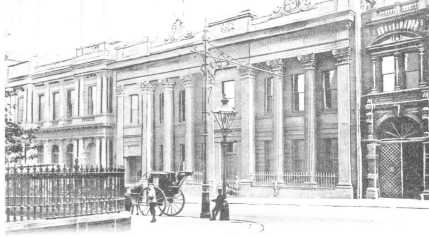

Cutlers' Hall, Sheffield

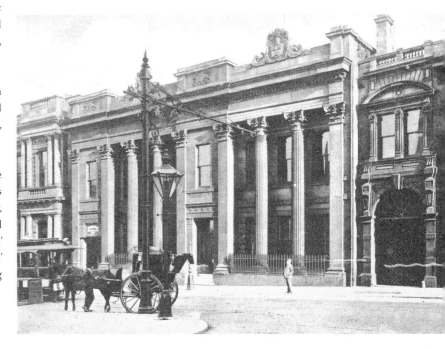

Above left: Church Street, Sheffield is illustrated with horse-drawn cabs, including a hansom cab and a wagon. The picture shows shop canopies and a few well-dressed shoppers window shopping. The shop to the right-hand side is offering homeopathic medicines, and at the time, Sheffield was a notable centre for the development of herbal and homeopathic practitioners. This is in a context of formal medicine being expensive, chemically based, and often very unsuccessful.

Above right: In the early 1900s, young boys are hanging around Cutlers' Hall, Church Street with a hansom carriage parked opposite, perhaps for visitors to the cathedral close by. One of the boys is leaning against a lamp post and they all have a pensive, nonchalant look; perhaps they are waiting to run errands for a tip.

Below right: In 1904, a man holds a horse and a carriage outside the cathedral and opposite the Cutlers' Hall on Church Street. Nearby is a horse-drawn tram or bus. The postcard is coloured and the artist has given the railings and street lamp an imaginative green colour, but if you look carefully you will see that this also includes much of the Cutlers' Hall stonework. The hall was built in 1832–3 and cost £6,500. It has the arms of the Cutlers' Company of Sheffield, which were apparently the same as those for the London Cutlers' Company even though the two were not connected. The main functions of the building were and remain grand; formal dinners and in particular the annual Cutlers' Feasts.

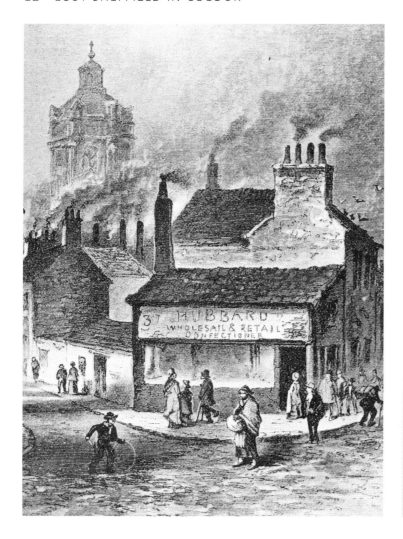

Left: A bit of Old Sheffield, around Pinstone Street, in the early 1800s with Hibberd Wholesale and Retail Confectioner and people huddled in shabby clothes. The picture gives a grim impression of the domestic smoke pollution from the ubiquitous coal fires of the time with the sunlight blacked out. A boy in the foreground is playing with a hoop.

Below: This scene depicts Fargate and Queen Victoria's statue in 1907 shortly after its unveiling, as schoolchildren, well dressed in bonnets, for example, look on, as do the passing adults. A man in a top hat drives a horse and cart, an electric tram is speeding towards us, and a man on a pedal bike is cycling away.

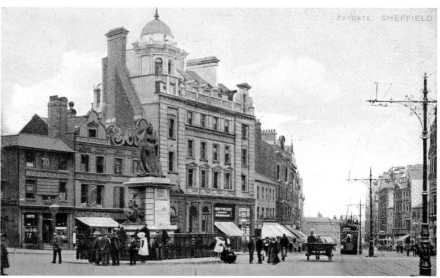

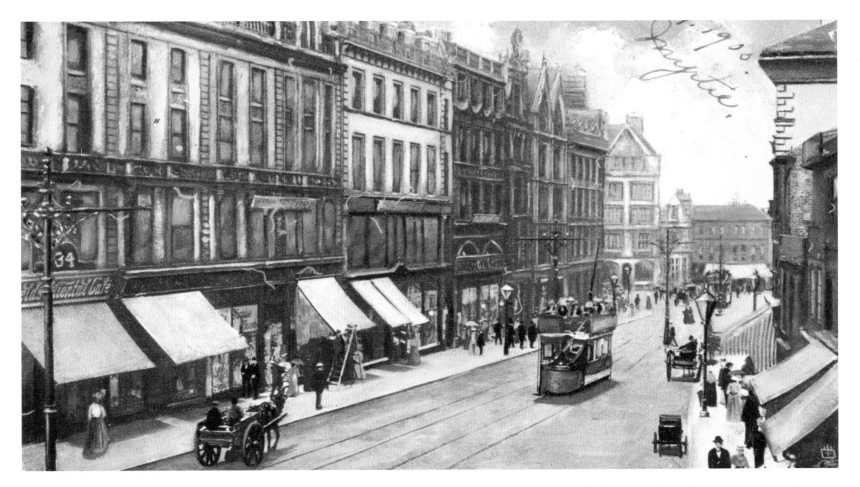

Fargate in Sheffield city centre is pictured in the early 1900s with shops, shoppers, trams and horse carts. Unusually, the view is from above, perhaps from the upper windows of one of the buildings. Some shoppers are sporting parasols.

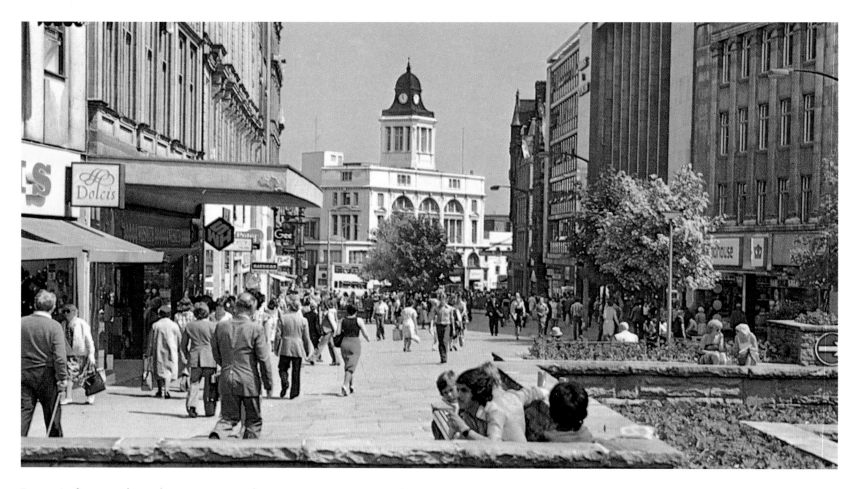

Fargate in the 1970s shows the more recent pedestrian precinct, 1970s street furniture, and some typical 1970s hairstyles; some things are best forgotten. The famous Telegraph Building is shown in the middle of the view.

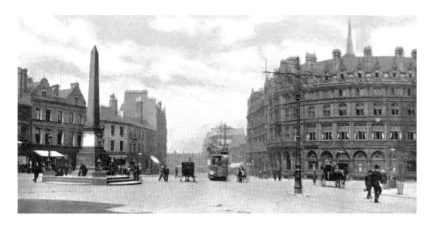

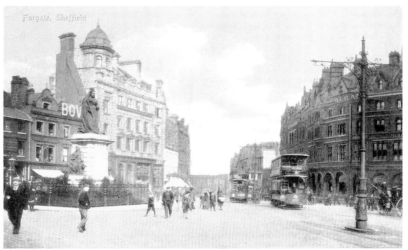

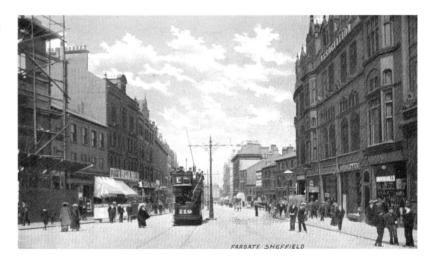

Above left: The picture shows Fargate with the Queen Victoria Jubilee 'monolith' memorial, erected in 1887, pictured with trams and carriages in the late 1800s. The name 'Fargate' is made up of a road, 'gate' and beyond the town, i.e. 'Far'. The memorial has long since gone, moved to Endcliffe Park and replaced by a statue of Victoria, but many of the buildings remain to this day. Note the new buildings that appear in the previous image, which are not in this picture of a few years earlier.

Above right: Fargate is pictured with the Victoria monument and trams. The statue was unveiled by Princess Beatrice in Town Hall Square on 11 May 1905 and then removed to Endcliffe Park on 24 February 1930. The scene is thronged with people (some clearly interested in the photographer) and has a delivery cart and numerous trams, both open-topped and closed.

Below right: Sheffield's Fargate with shoppers, building works and the 119 tram on a postcard posted from Boston, USA, in 1907. The scene appears quite sunny, though the sky is an artist's impression. Shoppers are well attired in heavy coats, capes and hats, and the schoolboys sport the ubiquitous caps of the time.

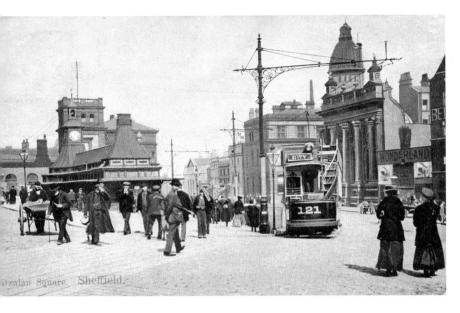

Fitzalan Square in 1906 with people, a street vendor, and tram number 121. By 1910, a new scheme was undertaken to redesign the square, which was formally opened by the Lord Mayor. The old cabmen's shelter was removed and the oval space in the centre of the square was rebuilt with facilities that were more modern. Shortly afterwards, the square gained the statue of King Edward VII and the new head post office was constructed at the western end.

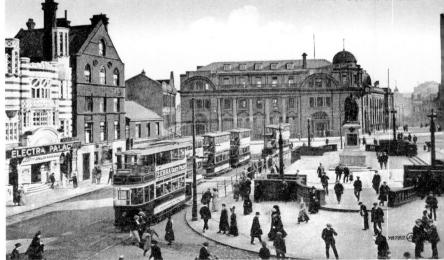

This is a view of Fitzalan Square in the 1920s with a row of trams outside the Electra Palace. The 'new', open space in the square is shown along with the statue of King Edward VII. One of the trams has a wonderful advert for Zebra Grate Polish, presumably a must for every house-proud housewife.

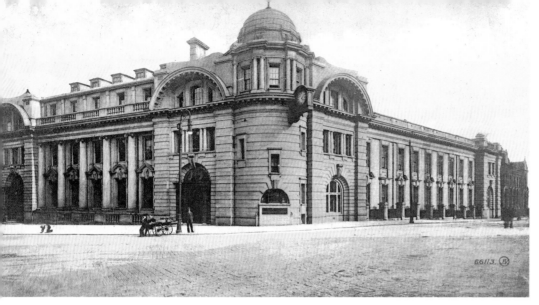

The general post office in Fitzalan Square was a major and prestigious new development in Edwardian Sheffield. Men with handcarts seem to be posing for the photograph, and another man on his hands and knees seems to be scrubbing the pavement.

Pictured around 1912, the general post office in Fitzalan Square is the same picture but given a different treatment and without the blue sky. At the far corner of the square was the Marples Hotel, a seven-storey building which received a direct hit from a high-explosive bomb during the Blitz on 12 December 1940. The building was destroyed and sixty to seventy people who had been sheltering inside were killed, including many women.

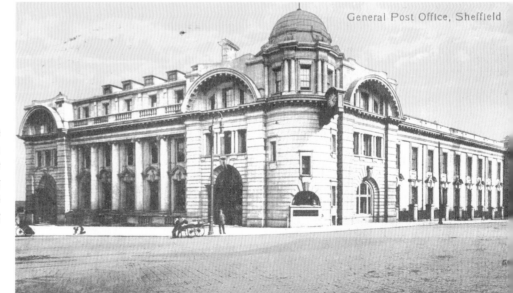

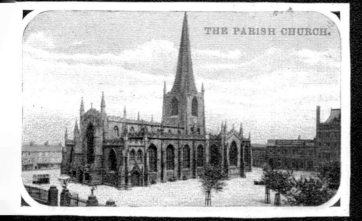

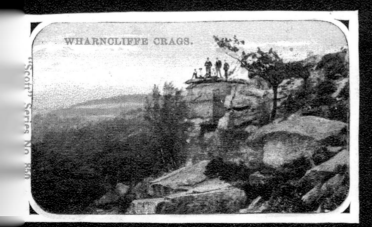

Above: Hartshead in 1895 is pictured by A. Wilson to show a bookshop and children playing a game, maybe marbles. One has a basket, with perhaps food, and a bottle probably of ginger beer or something similar. Girls in bonnets are peering into the windows and a gentleman stands in his cape on the threshold.

Left: A card entitled 'Greetings from Sheffield' and dating from 1906 shows the parish church, which had recently become a cathedral, and with newly planted trees in the foreground. Wharncliffe Crags is shown in the lower picture with a group of well-dressed visitors posed on the rocks. Situated to the north of the city, the Crags was a noted beauty spot and a picturesque tourist destination.

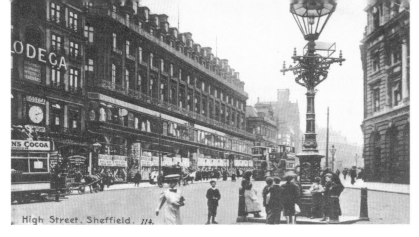

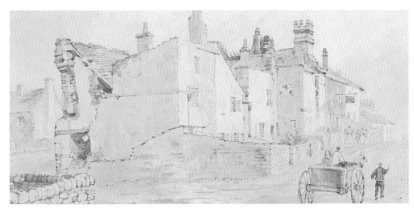

Manor Lane is portrayed in 1869 by C. T. Dixon with derelict and tumbledown houses as it led to the once splendid, but by this time decommissioned, Manor Lodge.

Above: Sheffield High Street is shown in the early 1900s, with trams and carriages. Outside the Bodega restaurant, children with caps and some with bare feet loiter under a rather grandiose street lamp. Advertising announces that John Walsh's sale begins today. On the morning of 19 June 1875, John Walsh opened a small outfitting shop for baby linen and ladies, at 39 High Street, Sheffield. This shop grew into a large department store, but was destroyed by the Sheffield Blitz in 1940. Acquired by Harrods in 1946, the store was then rebuilt in 1953 and renamed Walsh's. The Harrods Group was taken over by House of Fraser in 1959, and the store later renamed, firstly as Rackhams Sheffield in the 1970s, and then House of Fraser Sheffield in the 1980s. This store was closed in 1998, and the former Walsh's building was occupied by T. J. Hughes, which went into administration in August 2011.

Right: Moor Head, Sheffield, is shown in the early 1900s with the Crimea monument sculpted by Henry Lane (1863). It was later moved, minus the column, to the Sheffield Botanical Gardens, where, during recent refurbishment it was replaced by an ornamental statue, and surprisingly put into cold storage as a part of a scheme to revert the gardens to their original design. While appreciating the garden design ethic, one wonders about the memorial to the fallen of a bitter conflict, and our respect for and remembrance of them. I wonder, too, what happened to the column.

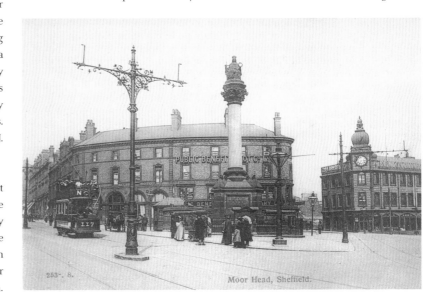

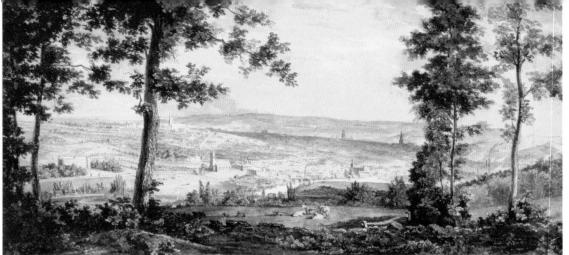

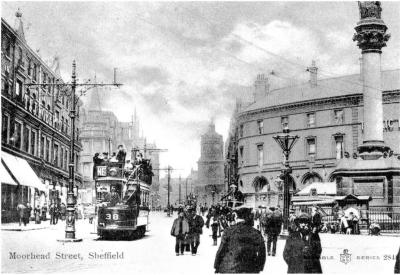

Moorhead Street, Sheffield

Above left: Old Hartshead, Sheffield, pictured in the early 1900s. In 1736, a private banker called Thomas Broadbent lived in the old Georgian House at Hartshead, and by the early 1800s, James Montgomery, the eminent poet and publisher, lived in the area, which was by then regarded as a rather grim place. He lived above the premises of his printing shop, retiring after thirty-one years in business in September 1825. Montgomery lived on until dying at the age of eighty-three on 30 April 1854.

Above right: In 1850 William Ibbitt painted a *North West View of Sheffield from Parkwood Springs*. 'Springs' refers not to the season or to water, but to the fact that this was the coppice wood or 'spring wood' for the park at Hillsborough, in days before the football ground or the current recreational park. It would have produced small-bore wood to make charcoal for the metal industries of Sheffield.

Below left: Moorend Street, 1906, with trams and the Crimea monument, and a busy street scene. The tram is the number 38 and the clouds look dark and ominous. St Paul's church is partly obscured by the apparent smog. As is often the case, waifs, strays and street urchins surround the monument.

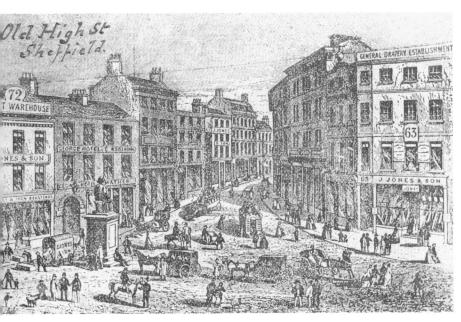

The old High Street in the early 1800s would have been at the top of Old Sheffield and leading up to Fargate. It was here, in the late 1700s, that the fledgling sculptor Francis (later Sir Francis) Chantrey worked in a shop that specialised in oil painting and engravings. His move from a grocer's shop was successful, and by the early 1800s he had his own studio at 24 Paradise Square. He was able to advertise that 'F. Chantrey, with all due deference, begs permission to inform the ladies and gentlemen of Sheffield and its vicinity that, during his stay here, he wishes to employ his time in taking portraits in crayons and miniatures, at the pleasure of the person who shall do him the honour to sit. Terms from two to three guineas, 24 Paradise square.'

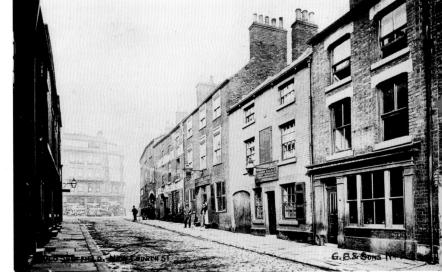

New Church Street in Old Sheffield in the 1920s was a cobbled street on tightly packed terraced properties running down the hill from the cathedral and close to Paradise Square. A man in a bowler hat stands outside the appropriately named Cutler's Arms public house.

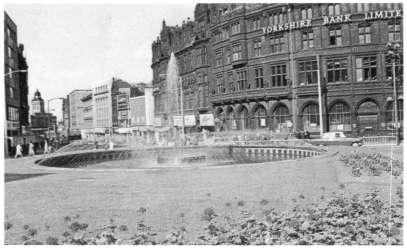

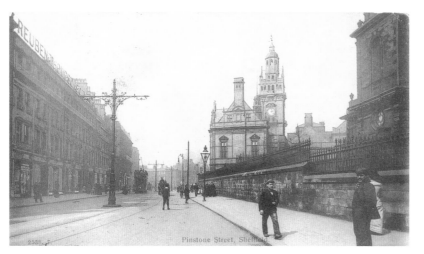

Above left: Pinstone Street is shown in 1908, with the Town Hall and St Paul's Church now gone. The scene is dotted with busy people, a horse and cart, a tram and a pedal cyclist.

Above right: By the late 1960s, Fargate had gained an ornamental fountain and flowerbed, but had not yet been pedestrianised. The Sheffield Corporation omnibuses, with the open rear doors like the one heading away towards High Street, were also about to be phased out for the front-loading, folding-doored Atlantis.

Below left: St Paul's Church and the old Town Hall are clearly shown on this 1904 image of Pinstone Street, with gas lamps, tramway, power lines and tram. On 20 January 1920 there were four investigations into the deaths of people knocked down and killed by tramcars. The doctor, called from the Royal Infirmary to provide expert opinion, stated that the cause was negligence and that the trams were being driven too fast!

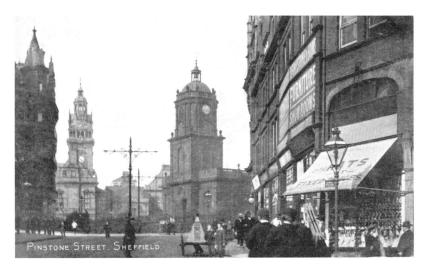

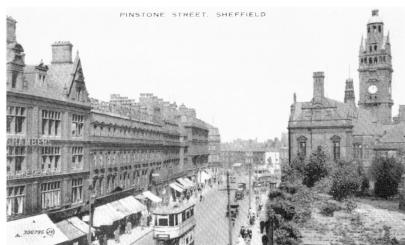

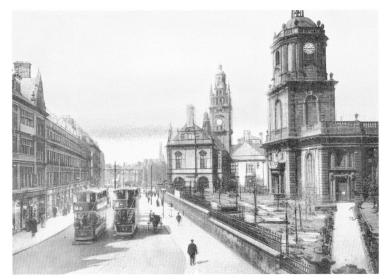

Above left: Pinstone Street in 1904, looking towards the Town Hall and the old church, with street vendors, smartly dressed men and boys, and a fascinating view of the hat shop.

Above right: Somewhat later in the early 1900s, Pinstone Street is now shown with trams, motorcars and the Town Hall. Visible is the now clearly derelict site of St Paul's church, overgrown with young trees and scrub, probably birch and willow.

Below right: Contrasting with the previous picture, Pinstone Street is shown here with trams passing the old Town Hall and St Paul's Church, with its grounds still well maintained. The foundation stone of St Paul's was laid in 1720, though because of a bitter quarrel about the right of presentation, it did not open until 1740. In 1769, a large dome was added to the structure to create one of the finest churches in the town. It was derelict sometime in the early 1900s (but clearly post-1910), and was demolished in 1938. Ornamental stonework ended up in other churches, and some was used as garden ornaments in the Bents Green area. A distinctive stone frieze is now on a house on Trap Lane, Fulwood.

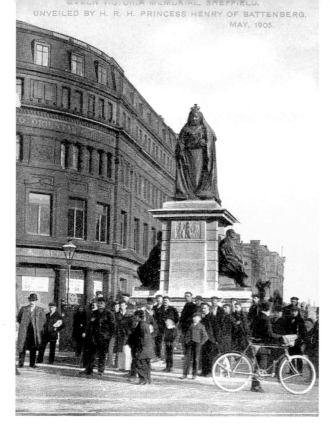

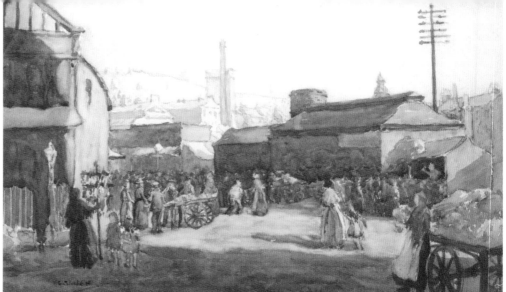

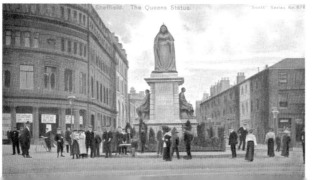

Above left: In May 1905, the Queen Victoria memorial was unveiled by HRH Princess Henry of Battenburg at the top of Fargate and opposite the old Town Hall.

Above right: In 1927, Herbert Slater painted *Outside the Rag Market, Dixon Lane,* with a busy street scene of vendors and the backdrop of industrial Sheffield. In 1899, Sheffield Corporation purchased all the markets and rights from the Duke of Norfolk, for the considerable sum of £526,000. Since that time, the markets have remained the property of Sheffield City Council. An agreement was reached between the duke and the Lord Mayor whereby 'the Duke will sell and the Corporation will purchase for the sum of £526,000 first the fee simple of all the market halls and places for holding markets and fairs slaughter-houses messuages buildings lands and hereditaments specified'. In 1928, Sheffield Corporation began work constructing Castle Hill Market, also called the Rag & Tag Market, Sheaf Market or Castle Market. The site was next to the former Sheffield Castle site, which had been purchased the year before by the Brightside & Carbrook Co-operative Society, and during building excavations the castle ruins were discovered.

Below left: Queen Victoria's statue is shown in 1906, looking towards Leopold Street.

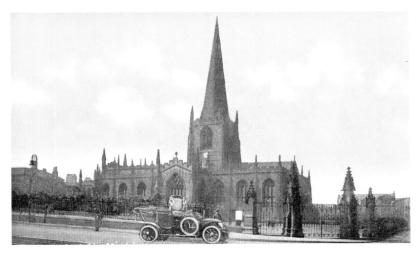

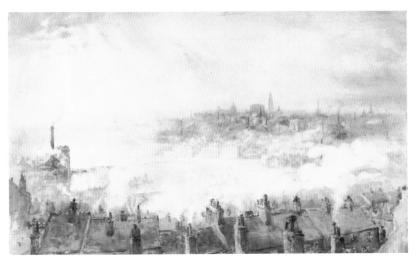

Above left: This is a view of Sheffield Cathedral, with chauffeur-driven limousine and the huge ornamental gates and iron fencing around the site.

Above right: In 1909, A. Holland painted *Sheffield from above the Midland Station* and this shows dramatically the desperately poor state of the city's air. The sunlight is clearly trying to break through, but this is a losing battle against the accumulated smoke from massed houses and industry.

Below right: Herbert Slater in 1927 portrayed *Sheffield from Rock Street, Pitsmoor,* giving a vivid impression of the housing and the industry with associated air pollution.

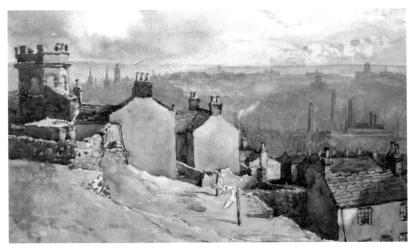

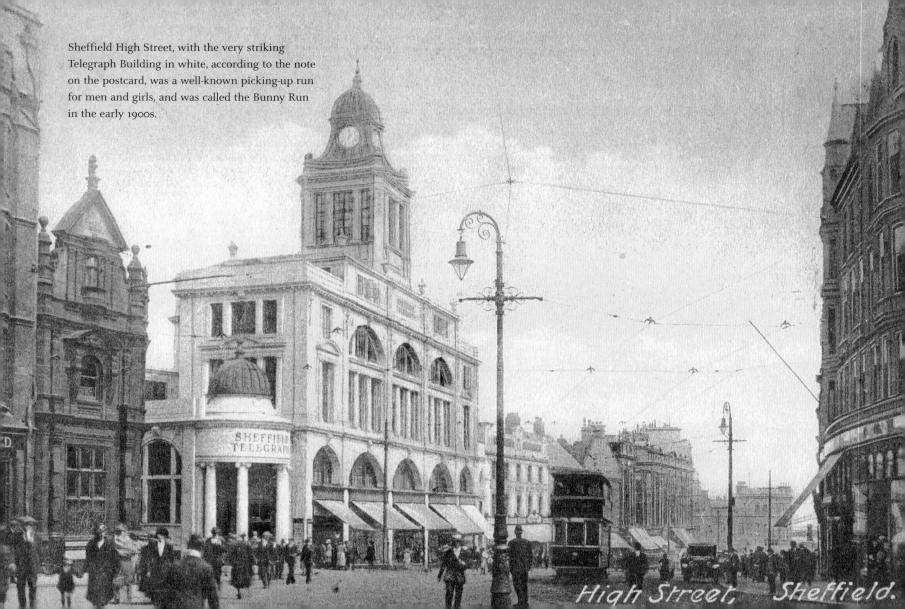

Sheffield High Street, with the very striking Telegraph Building in white, according to the note on the postcard, was a well-known picking-up run for men and girls, and was called the Bunny Run in the early 1900s.

High Street, Sheffield.

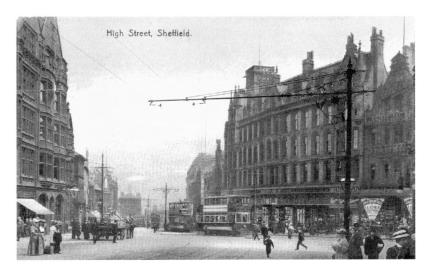

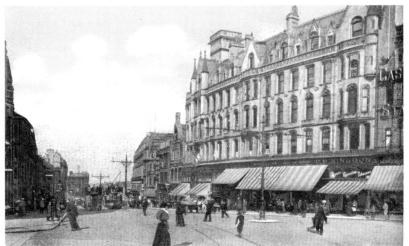

Above left: This image of the High Street in Sheffield on a postcard sent in 1908 gives a vivid impression of the double-decker trams, the shoppers finely decked out in frocks, coats and hats, and a delivery horse and cart. Shops selling leather goods, stationery, and more are shown where Boots the Chemist now stands.

Above right: In the early 1900s, Sheffield High Street is portrayed to show the vivid shop-front canopies, the open-topped trams, and shoppers bustling around the pavements, shops and the street.

Below right: This picture, posted in 1909, but of an earlier scene, shows Sheffield High Street with finely dressed shoppers, open-topped and closed trams, a horse-drawn bus, hansom carriages, and carts of various types. The shoppers are carrying umbrellas against the rain, or perhaps parasols to protect them from the sun, and the buildings show the staining of smoke and grime typical of Sheffield at that time.

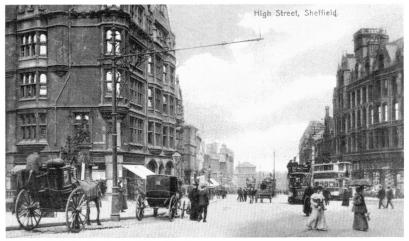

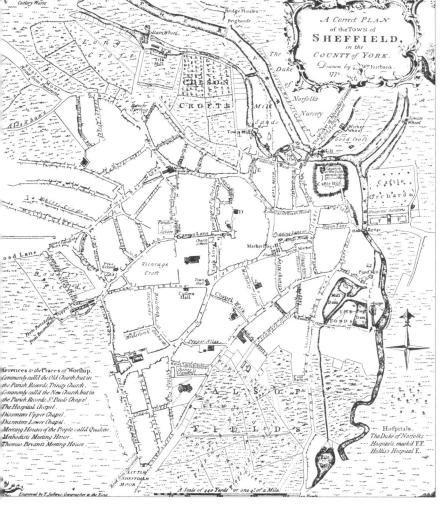

Sheffield in 1822, engraved for the History Directory of Yorkshire.

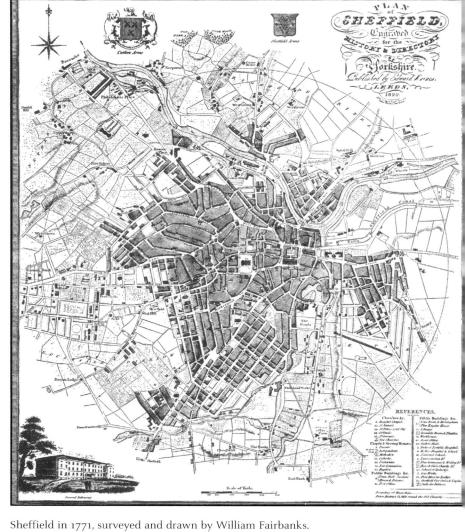

Sheffield in 1771, surveyed and drawn by William Fairbanks.

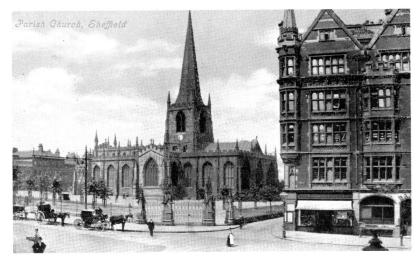

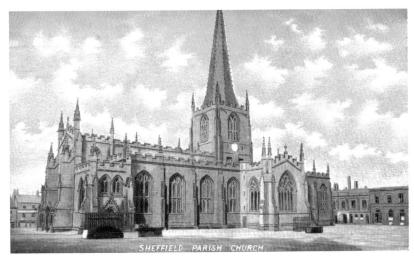

Above left: Sheffield's parish church, later the cathedral, and a view of Norfolk Row around 1905, with miscellaneous carriages parked along the roadside, and what appears to be a shop girl crossing the road. Note the planted trees in the forecourt of the cathedral.

Above right: Sheffield's parish church in the early 1900s, by this time a cathedral, but without the planted trees and in a very open setting.

Right: Sheffield Town Hall, built in 1896, and the Jubilee monuments in the early 1900s. The Town Hall was formally opened the following year in 1897 by Queen Victoria. This is one of the city's most impressive buildings and is adorned with stone carvings, such as an owl and a pelican added in 1923, supposedly to represent the wisdom and intelligence of the City Council. There is also the frieze of skilled artisans and tradesmen, such as smiths, smelters, miners and others, and on top of the clock tower, 210 feet up, is a statue of a naked Vulcan, the god of fire and metalworkers. According to Edward J. Vickers, the statue weighs 18 hundredweights and is 7 feet high, even though it seems tiny from street level. The statue was apparently modelled on one of Queen Victoria's Life Guardsmen, though whether he posed 'kit off' is unstated.

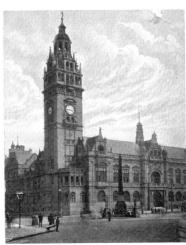

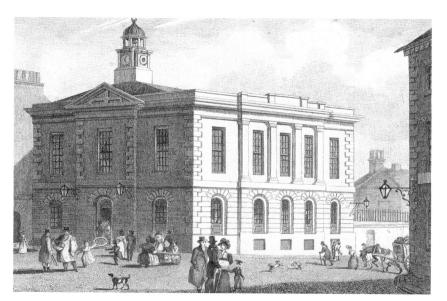

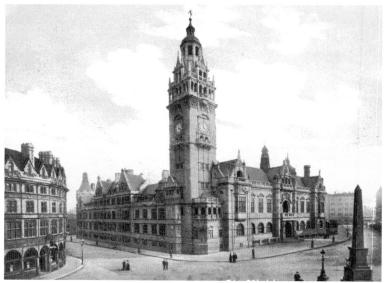

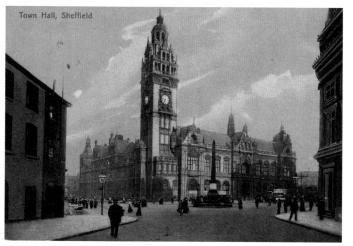

Town Hall, Sheffield.

Above left: This picture is by N. Whittock and shows a street scene with people walking by and children playing outside the original Sheffield Town Hall around 1830. The building, situated at the corner of Waingate and Castle Street, was erected in 1833, and was used for political and administrative functions, as well as acting as a courtroom. The political and administrative functions transferred to the new 'old' Town Hall, and the judiciary use continued until the relatively recent building of the new courthouse.

Above right: The photograph here on a 1906 postcard shows Sheffield Town Hall, again with the obelisk, so pre-1905. The picture is also before the electric tramways, cables and tramlines.

Below left: Sheffield Town Hall from Leopold Street, on a postcard posted in 1908 with the Jubilee memorial and what appears to be a motorbus in front of the hall. As the obelisk had been moved some years previously, this must have been quite an old photograph when it was posted.

Above: Sheffield's 'old' Town Hall on a 1912 postcard, but again using a picture that includes the Jubilee obelisk, but which has not gained the memorial statue of Queen Victoria. A group of people seem to be posing around the memorial and again there are no trams to be seen.

Below: This photograph shows the 'old' Town Hall and St Paul's Gardens, the Peace Gardens, as they were in the 1970s. The roofs of the covered bus stops are visible just over the wall to the left of the picture.

Far right: This view is of Sheffield Town Hall on a card posted in the 1920s, and by now, the scene has gained the electric tramway, cables and tramlines. In the foreground, a man is striding out wearing a fine boater, and the picture shows the main Town Hall entrance.

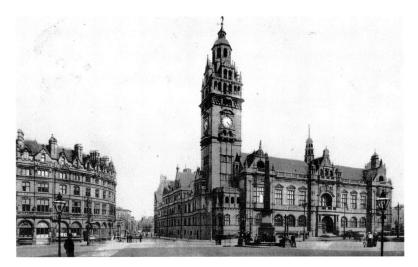

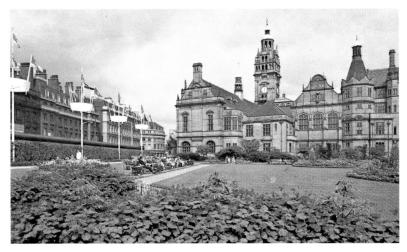

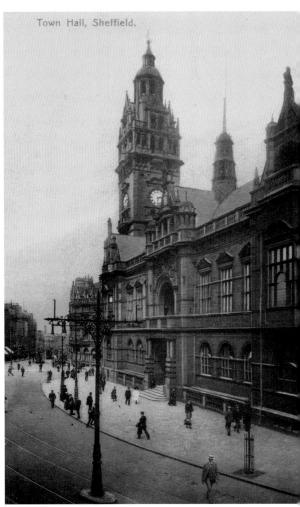

Town Hall, Sheffield.

Above: A. Wilson, painting in 1895, has captured the essence of 'Snig Hill' with its old Tudor buildings. It is hard to imagine the old Sheffield of the image in the city of today.

Right: Some of the last remnants of medieval or Tudor Sheffield on Old Snig Hill, still occupied as homes and shops in the early 1900s, but soon to be swept away in the twentieth century. This photograph shows the same buildings as portrayed by Wilson, but now in complete disrepair and dilapidation.

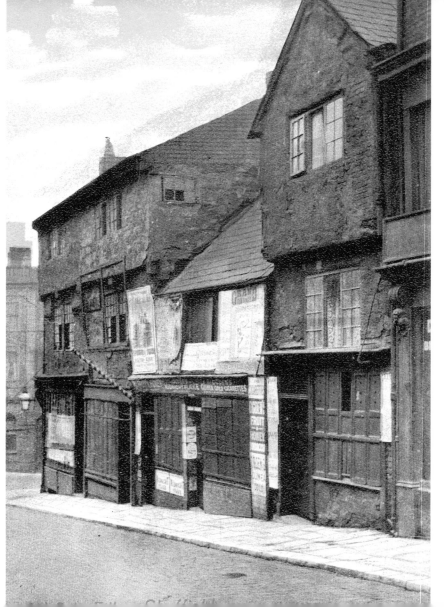

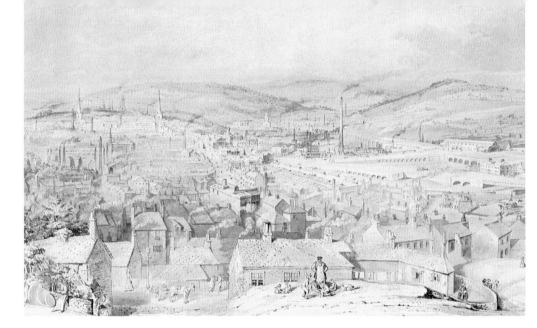

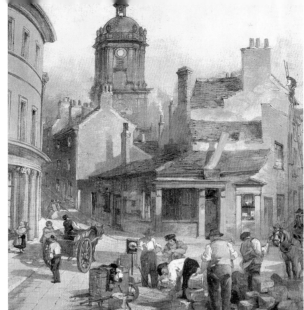

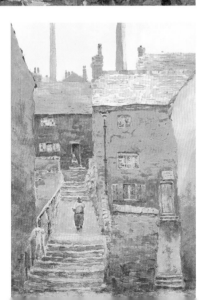

Above left: In 1854, W. Ibbitt painted *South East View of Sheffield*, and looking to the north we see Parkwood Springs still clothed by a coppice wood, the city dominated by smoke stacks, and the Victoria railway line and station.

Above right: G. Sykes' painting in 1858 shows St Paul's Church from Union Street, where some old buildings and little mesters' works remain, though they are generally dilapidated, and demolition or fires have taken their toll in recent decades. It is hard to visualise a scene like this in the area today.

Below right: In 1903, the Pond Street area, now Sheffield's main transport interchange, looked a little different. Here it is portrayed by W. Boden in *Steps in Pond Street*.

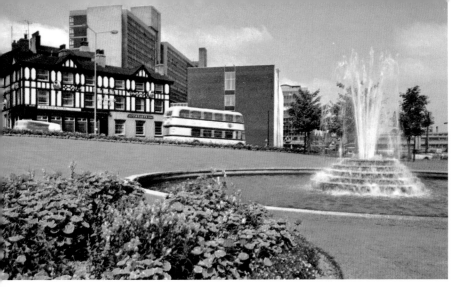

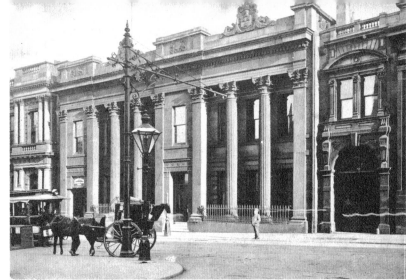

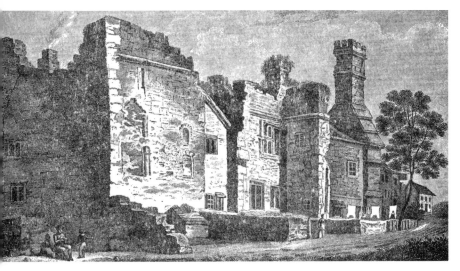

Above left: This view of the Midland Station roundabout in 1960s Sheffield captures the landscape that is now replaced by the thoroughly modern development which provides a gateway to Sheffield. The open-door bus and the roundabout with a fountain give a feel for the time. The buildings of the old Sheffield City Polytechnic are now integrated into Sheffield Hallam University's City Campus.

Above right: The Cutlers' Hall on Church Street is shown as it was by the early 1900s with a small boy, a tram and a carriage.

Below left: The Manor House, or Manor Lodge, Sheffield, is shown in the early 1800s; mostly derelict but apparently in part still occupied. This was the centre of one of the greatest deer parks in medieval England, with abundant deer and enormous oak trees. All this was seated over rich mineral resources of iron and of coal, which was the park's eventual undoing. The Manor Lodge is the reminder of what was once a significant mansion, and it still stands, now as a museum, on Manor Lane.

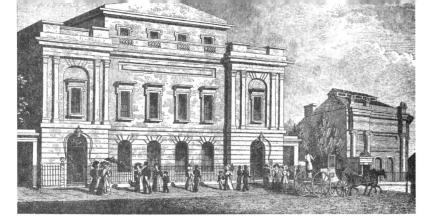

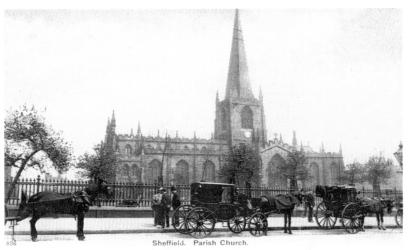

Above left: The Music Hall, Sheffield, is shown in the early 1800s. This was a stone building in Surrey Street, built in 1823 and opened in 1824 by a company whose secretary was a Mr Freemantle of High Street, Sheffield. The large room held up to 1,000 people, was adorned by portraits of famous composers, and had its own organ. The lower floor was occupied by the Sheffield Library and the Literary and Philosophical Society. Music Hall, Surrey Street later became the public library (Sheffield Central Lending Library and Reading Room). It was demolished in the 1930s to make way for the new Central Library.

Above right: The parish church of St Peter and St Paul, Sheffield, in the late 1800s with a variety of horses and carriages parked outside and the planted trees now well established. The various carriages and their drivers might be waiting for customers from shops, visitors to the cathedral, or even to the Cutlers' Hall opposite.

Below right: Sheffield's parish church is shown at an earlier date than in the previous photograph, with the iron railways and gates enclosing only a limited area and no planted trees. This is an early photograph, which is finished by an artist, and the men are clearly posing for the picture.

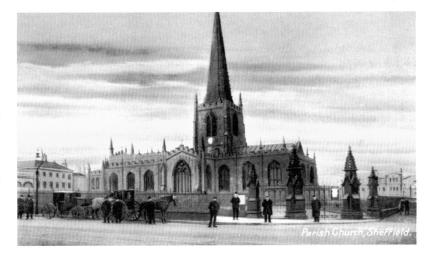

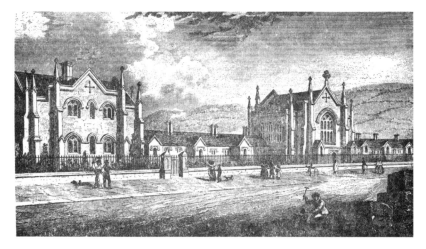

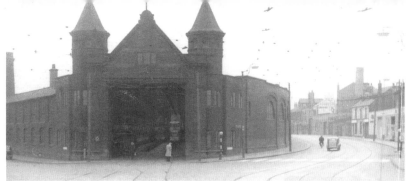

Above left: The print shows the Shrewsbury Hospital in the early 1800s. The charity was founded in 1616 by Gilbert, Earl of Shrewsbury, and it owned a building by Lady's Bridge. It then occupied the site of the later Corn Exchange and the Haymarket. This building was demolished in 1827 and a new site was developed on Norfolk Road, close by the Cholera Monument. The Shrewsbury Hospital when built on Norfolk Road had extensive grounds, well-appointed almshouses and a chapel. Past owners included earls of Shrewsbury and dukes of Norfolk, and the building was built in Tudor-Gothic style to house twenty male and twenty female pensioners and a governor-chaplain. In the picture you can see the farming landscape of fields in the near distance.

Above right: This photograph, taken on Sunday 13 April 1958, shows the tram sheds, Leadmill Road. The area is now dominated by student apartments, the Leadmill nightclub, BBC Radio Sheffield, the Sheffield Archives, the Showroom Cinema, and the Red Tape Studio.

Below left: The teaching college at Collegiate is pictured in the early 1900s. The college began as Collegiate School, which was a boarding school for juniors and a university preparatory school for seniors. It became the Sheffield Royal Grammar School in the 1880s, and in 1906 was converted into the University of Sheffield Teachers' College. In 1911, the college became the City of Sheffield Training College, but in the First World War was converted to use as the 3rd Northern General Hospital.

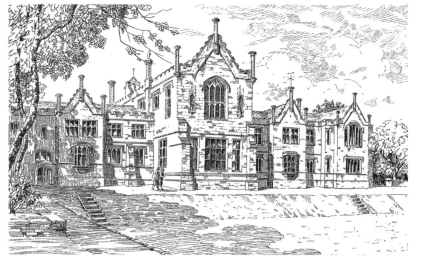

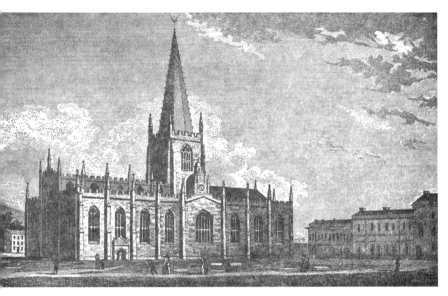

Sheffield's parish church, Trinity Church, is pictured in the early 1800s. The original William de Lovetot founded the current church building in the twelfth century. There was probably a small wooden Saxon church here, and a stone Saxon cross was erected around AD 825 but was removed on the orders of Queen Elizabeth I, and eventually moved to the British Museum. Another Norman overlord, Thomas de Furnival, rebuilt the church in 1280; this followed the sacking of the town, castle and church during the civil war between the king and the barons.

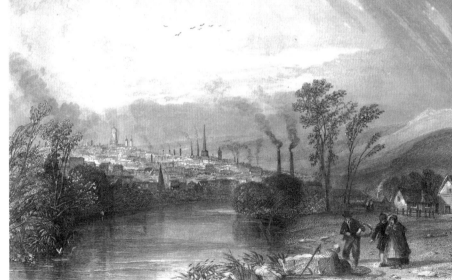

This view of Sheffield from the Don Valley in the 1820s gives a dramatic image of the town that was rapidly growing as a major industrial centre. The buildings and the nearby hills are exaggerated by the artist to make them look particularly spectacular.

Up the hill from Sheffield University are Broomhill and Crookesmoor and, until the 1700s, the latter was indeed heather moorland. Small areas of heath survived until the 1970s, when Sheffield University built tennis courts on the last bits, and more recently in the 1990s, when housing spread onto the former playing fields off Crookes Road. T. C. Holland painted *Sheffield from the Reservoirs, Crookesmoor* in 1826.

2

INDUSTRY AND COMMERCE

Sheffield grew from a little under 10,000 people in the 1600s to 30,000 by the early 1800s, and around 400,000 by the 1900s. The town expanded to a city, the urban sprawl subsuming smaller settlements as it grew. Metalworking and tool manufacture grew from crafts scattered in rural locations across the region, to major industries in great factories and dense groups of the famous 'little mesters' workshops. South-east of the town centre, around Arundel Street and today's Sheffield Hallam University, a new Victorian planned town expanded along a grid of cobbled streets, some still visible today.

This is a humorous view of Edwardian Sheffield and its air pollution, with a note to say, 'A fine day in Sheffield – the sun was last seen five days ago.' Ironically, by the 1960s, this situation and the reputation were turned around and Sheffield became a city with a global reputation for its clean air.

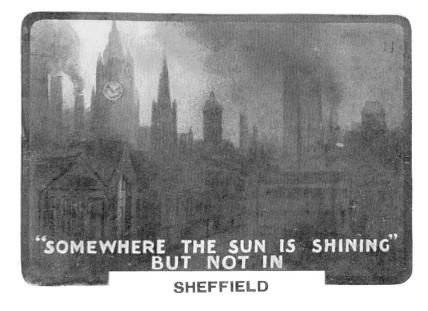

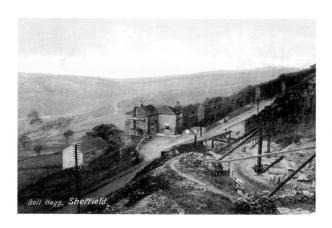

Bell Hagg, Sheffield.

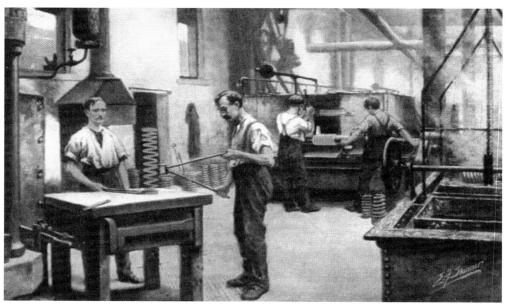

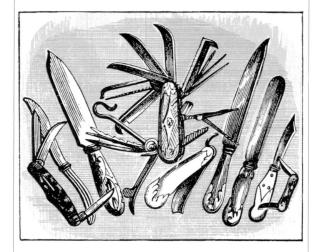

SHEFFIELD

Steel Works and Cutlery, and Electro Plate Factories.

POPULATION, 511,740.

Above left: This image shows Bell Hagg in the Rivelin Valley in 1910, with the working quarry where the garden centre is now located and the Bell Hagg Inn opposite. A part of Sheffield's growth and wealth was based on good-quality ganister, very hard, fine sandstone for industrial refractories and good sandstone for building. Dotted across the region are hundreds of quarries, large and small.

Above right: Sheffield grew into a centre for specialist industrial skills, especially for metalworking and related activities. The picture shows workers coiling red-hot springs at Cammell Laird in the First World War.

Below left: A celebration of Sheffield, its population and its industry is shown in this card, which states a population of 511,740 and boasts of steelworks, cutlery and electro-plate factories.

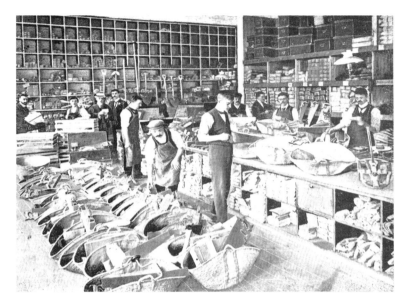

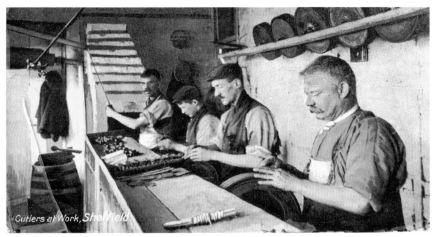

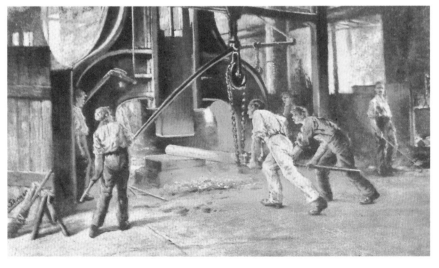

Above left: Mall tool and sharp tool manufacture were at the heart of Sheffield's industrial development. The card shows men examining tools before despatching them at J. G. Greaves' Tool Factory, 1904. Note the tools bundled up into typical baskets.

Above right: The Sheffield cutlery industry grew over the centuries until Sheffield became the leading centre in the world, and a by-word for high quality. Here we see cutlers at work in Sheffield in 1914.

Below right: The heat of the factories was unbearable. In this scene, hot metal is being manipulated as the men are busy forging bloom for axles at Cammell Laird in the early 1900s.

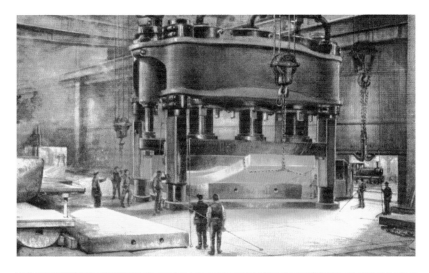

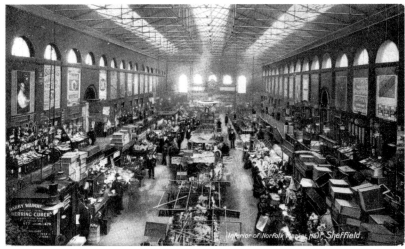

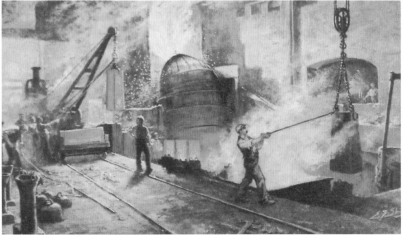

Above left: Sheffield's industry was at the core of national defence, as demonstrated by this image of men making armour plate at Cammell Laird in the First World War. They are using a 12,000-ton press.

Above right: This postcard, sent in 1907, shows the interior of Norfolk Market Hall. This was the principal market in Sheffield and was generally known as the 'New Market'. Opened in 1851, it occupied the former site of the Tontine Hotel, purchased by the Duke of Norfolk for £8,000 for developing the market. The overall cost of the project was around £40,000. The hall was 296 feet long, 115 feet wide and 45 feet high in the centre. Commerce and markets were at the heart of any emerging Victorian township.

Below left: It is almost impossible to appreciate the appalling heat and the most arduous conditions experienced by workers in Sheffield's steel factories. This is a picture of the making of Bessemer steel in the early 1900s.

The view here is of John Brown's Atlas Steel and Spring Works around 1875. Note the Midland Railway in the background and the carts, wagons and carriages in the fore. In addition, there is a typical, perhaps small-gauge, industrial railway running inside the factory complex.

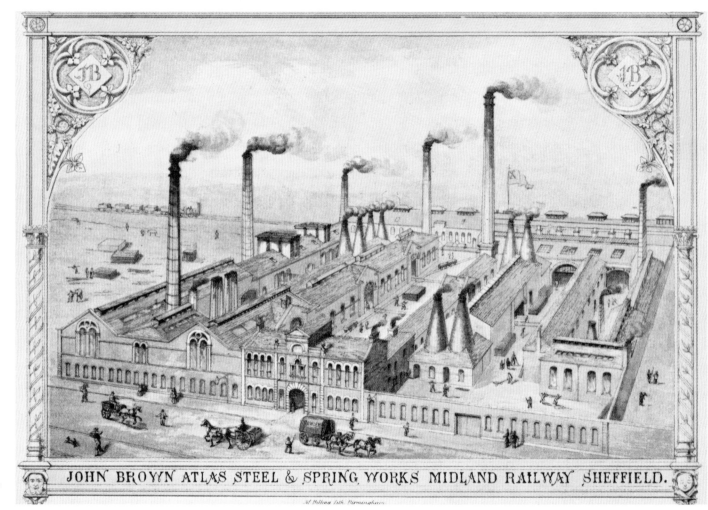

JOHN BROWN ATLAS STEEL & SPRING WORKS MIDLAND RAILWAY SHEFFIELD.

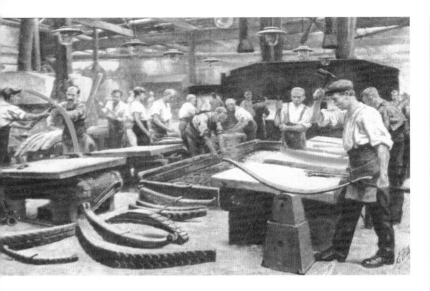

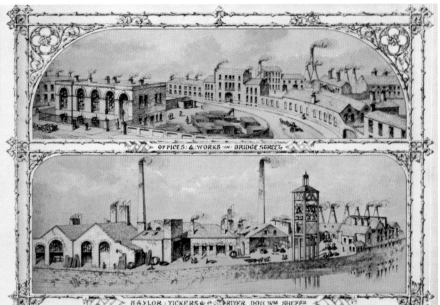

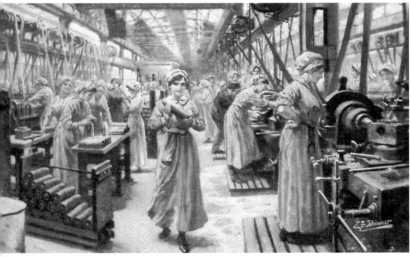

Above left: Making laminated railway springs at Cammell Laird in the First World War. This gives a good idea of the number of men involved in the factories, all with particular and specialist skills. These factories soon grew to employ around 70,000 men directly.

Below left: In wartime, metal, armaments and explosives go together. Munitions workers are shown at Cammell Laird in the First World War. Much of the badly contaminated waste from some of these factories ended up in unsealed, uncontrolled landfill sites, such as the one close by the M1 motorway at Droppingwell.

Above right: This image in the mid-1800s presents the offices and works at Bridge Street, Naylor & Vickers, with the River Don in the foreground.

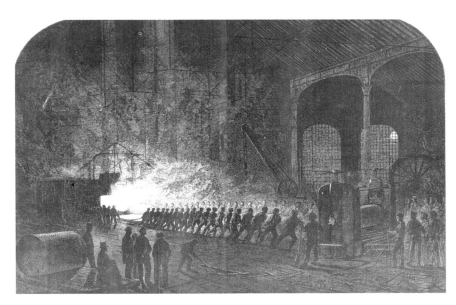

Above: As warships moved from the old timber galleons to armour-plated ironsides, the process of rolling armour plate for her majesty's ships became of huge national importance. This Victorian print shows the workers at the Atlas Steelworks, Sheffield, in 1861, hauling out red-hot plate from the rolling mill.

Right: This postcard from the early 1900s shows an old grinding wheel and works in the Rivelin Valley. This is typical of the small works powered by water across the whole region. Many of the river valleys retain archaeological remains of mills in various states of restoration or abject dereliction. The Porter, the Sheaf, the Rivelin and the Loxley all have excellent examples, with mills to be seen at Abbeydale Industrial Hamlet on the River Sheaf, and Shepherd Wheel on the Porter Brook.

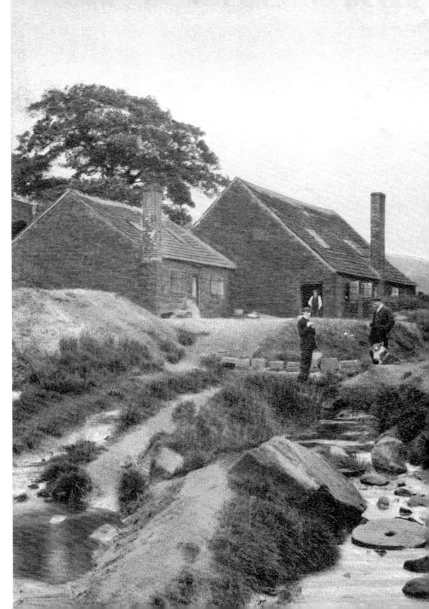

Sheffield is viewed from Psalter Lane at Brincliffe Edge in a painting by I. McIntyre in the 1800s, with grindstones and the quarrymen and their machinery clearly shown.

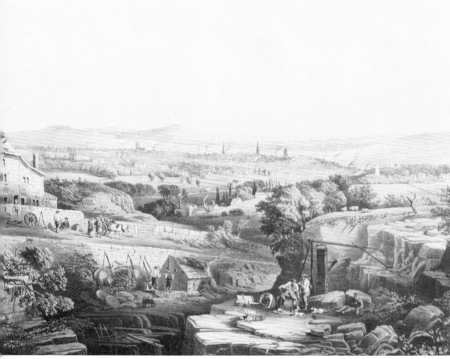

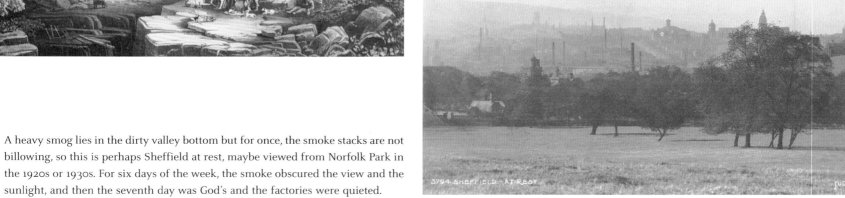

A heavy smog lies in the dirty valley bottom but for once, the smoke stacks are not billowing, so this is perhaps Sheffield at rest, maybe viewed from Norfolk Park in the 1920s or 1930s. For six days of the week, the smoke obscured the view and the sunlight, and then the seventh day was God's and the factories were quieted.

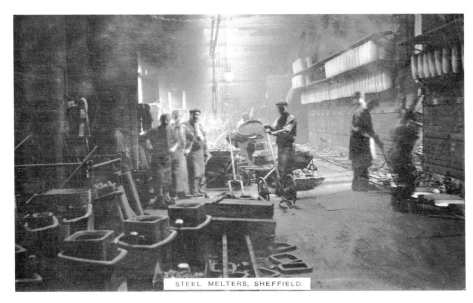

STEEL MELTERS, SHEFFIELD.

Above: Sheffield steel melters are shown in 1914 with the refractory crucibles lined up on the wall behind them.

Right: This image shows typical Sheffield knife grinders in the early 1900s. The city mixed enormous steel factories with hundreds of smaller, individually owned little mesters' works, with men grinding knives or making files.

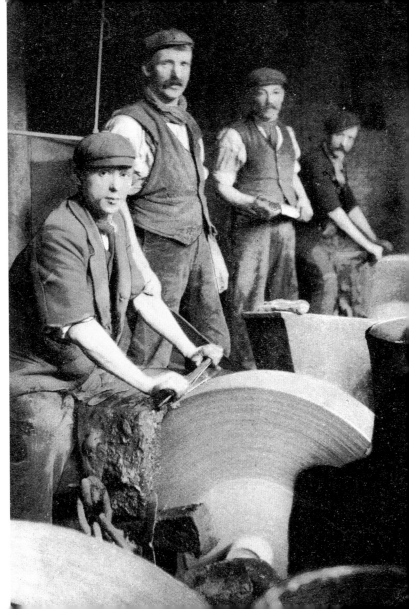

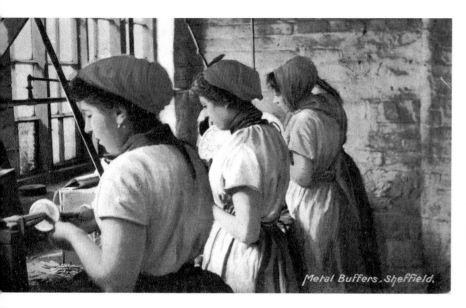

Metal Buffers. Sheffield.

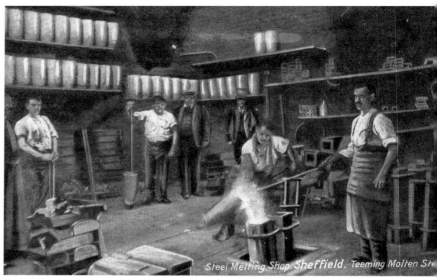

Steel Melting Shop. Sheffield. Teeming Molten St

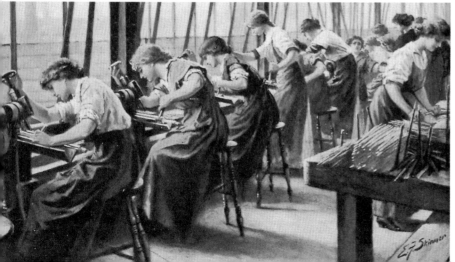

Above left: Sheffield's famous buffer girls are illustrated in this postcard posted in 1905. This was the finishing process for the cutlery made by the men and from the steel produced in the great factories. Many hundreds of women were employed in this equally hard and skilled work.

Above right: In the steel melting shop shown in the early 1900s, men are teeming molten steel while others look on, including one who is perhaps a supervisor, probably there for the picture.

Below left: Factory girls are shown here working at Cammell Laird in the early 1900s, but in this case without any head covering or other protective clothing. They don't appear to be buffing but are all engaged in some other, quite precise, task. The items stocked on the adjacent bench look like files or some other metal component.

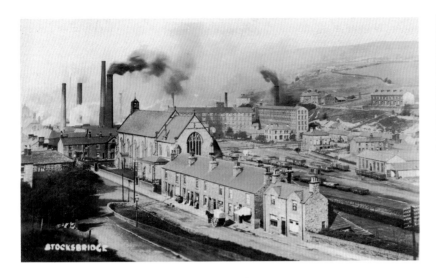

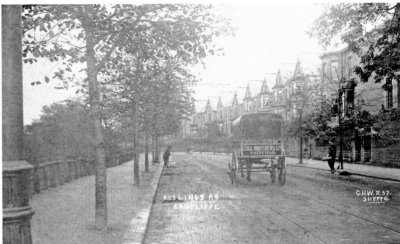

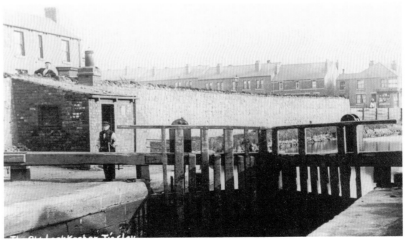

Above left: Sheffield industry expanded along each of the arterial river valleys that run, like the spokes of a wheel, from the city centre. This photograph shows Stocksbridge Steelworks on the Upper Don around 1900, billowing dark smoke into the atmosphere. Stocksbridge was a linear settlement along the valley bottom, where the people and the economy were dominated by the steelworks and the associated service industries.

Above right: Then, as now, local commerce would deliver to their customers and this image shows a Cole Bros (general drapers) delivery cart, on Rustlings Road, Endcliffe around 1904.

Below right: Industry demanded efficient transport and this picture, of the early 1900s, shows the old lock keeper at Tinsley Lock. The Sheffield and Tinsley Canal was a great step in connecting Sheffield's heavy industries with the outside world, but was soon overtaken by the railways.

YEAR KNIFE

MADE IN 1822: CONTAINED 1822 BLADES,
EACH BLADE WILL OPEN AND SHUT.

JOSEPH RODGERS & SONS, LTD.
SHEFFIELD.

TRADE ✳✳ MARK

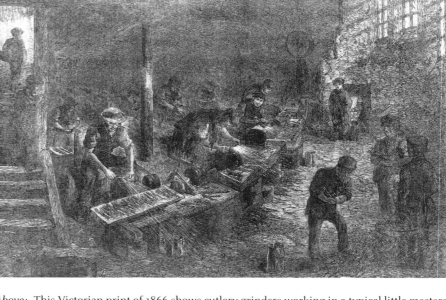

Above: This Victorian print of 1866 shows cutlery grinders working in a typical little mesters' shop. The skilled men work at individual grindstones and wear safety glasses to protect their eyes from hot, sharp slivers of metal. The picture was entitled *The Sheffield Steel Manufacturers – the Hull of the Fork-Grinders* and is a nice insight into a Victorian view of Sheffield.

Left: The Year Knife, as displayed at Weston Park Museum, was made in 1822 and contained 1822 blades, which was a world record.

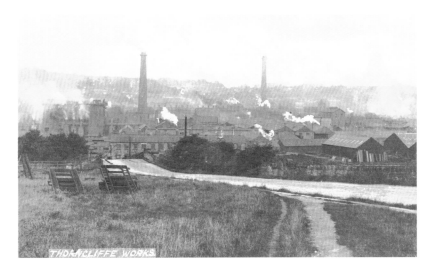

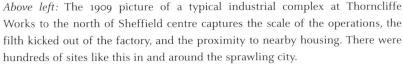

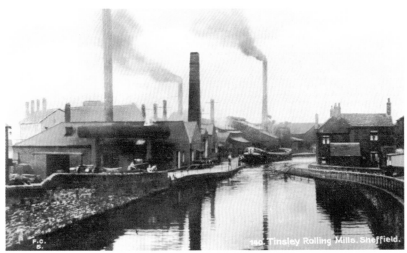

Above left: The 1909 picture of a typical industrial complex at Thorncliffe Works to the north of Sheffield centre captures the scale of the operations, the filth kicked out of the factory, and the proximity to nearby housing. There were hundreds of sites like this in and around the sprawling city.

Above right: The heavy gloom and the dirt are shown in this image of the Tinsley Rolling Mills by the Sheffield and Tinsley Canal in the early 1900s. A large barge awaits instruction and a load by the canal side, and the chimney pours thick black smoke into the air.

Below right: This image is of workers manipulating, handling and preparing or turning heavy shells at Cammell Laird in the First World War. Sheffield not only made the armour plate but the shell cases too.

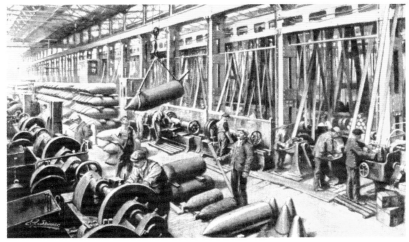

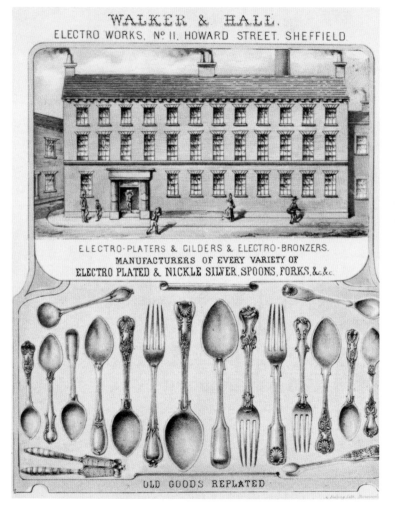

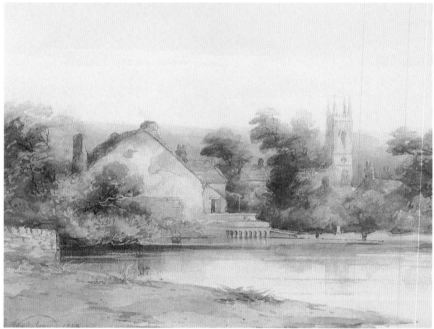

Above: The 1833 painting, by G. Nicholson, is of Vulcan Dam and Ellin Street. This shows Bennett Wheel, or Sheffield Moor Wheel, and Vulcan Dam on the Porter Brook, with St Mary's Church in the background.

Left: This promotional card features Walker & Hall Electro Works, Howard Street, around the mid-1800s. They are offering all varieties of electro-plated or nickel silver cutlery manufactured, and cutlery or other old goods re-plated.

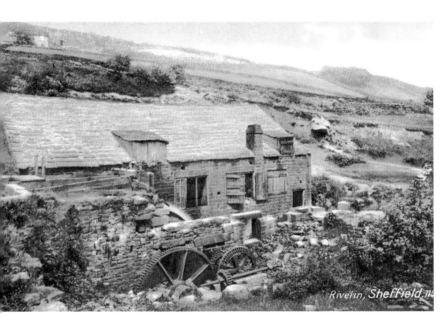

This picture from the early 1900s shows an overshot waterwheel and mill in the Rivelin Valley. The major wheels and drive shaft are shown as they take the power from the wheel to the works. Walk along the Rivelin Valley today, search for the remains of the old mills, and notice how much more wooded the landscape is.

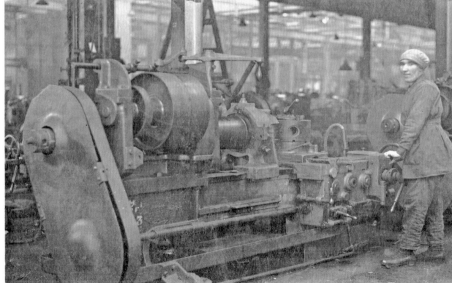

This photograph shows a First World War munitions worker with protective headgear operating a major piece of power equipment. Note the lack of any breathing protection for this worker, or those shown in the other pictures. Many Sheffield factory workers died slow and painful deaths due to inhalation of metals and other chemicals in the confined and poorly ventilated spaces of the workplace.

AROUND AND ABOUT SHEFFIELD CENTRE

The great factories grew and spread across the landscape with tongues of heavy industry reaching varyingly up and along each of the river valleys. From large factories to smaller mesters' workshops, the workers and skilled craftsmen grew in number and their traditions and cultures developed to become the lifeblood of the emerging city. Civic pride and the town's wealth were reflected in grand buildings, both public and private. The town centre acquired status buildings like the Town Hall and the Cutlers' Hall, while, especially in the western suburbs, private wealth was spent on grand villas and expensively landscaped gardens. They were simply the best in the world.

As Sheffield grew, it also attracted and generated great events, from royal visits to public festivals.

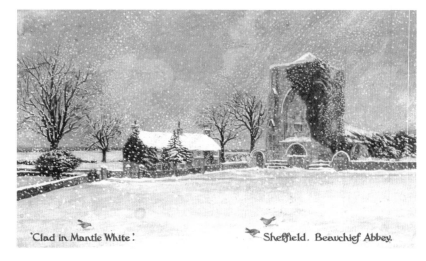

'Clad in Mantle White'. Sheffield. Beauchief Abbey.

This card from the early 1900s shows the then rural Beauchief Abbey 'clad in white', with a Christmas feel and birds in the foreground that appear not to be British. They look most like American robins, which are cousins of our own blackbirds.

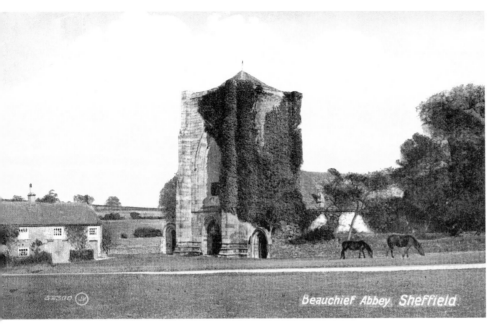

Above: This is an interesting view of Beauchief Abbey from a card posted in 1909. The scene is still very rural and without the great urban sprawl of Sheffield that transformed the area in the next fifty years or so. There are grazing horses, old cottages with wooden slat fencing, and a rural landscape beyond. Today, the mid-ground is a golf course and beyond that is urban housing.

Right: The ivy-clad Beauchief Abbey is illustrated on a postcard sent in 1906. A group of people, perhaps a family, cluster in the ancient doorway of the church, which is a reminder of the once great abbey.

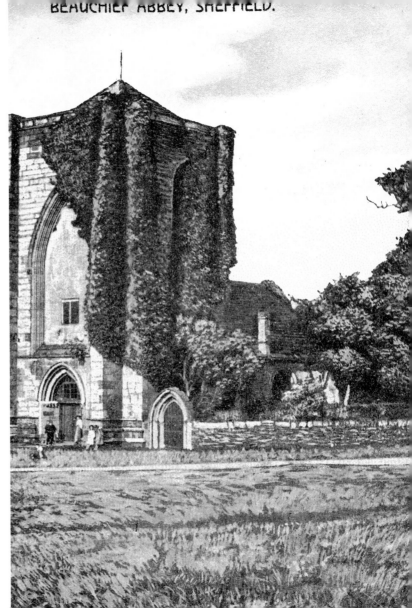

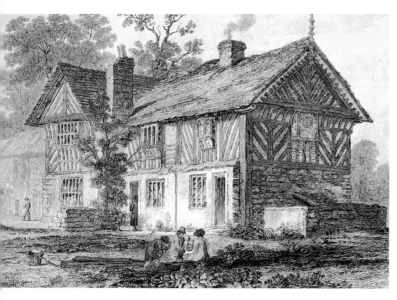

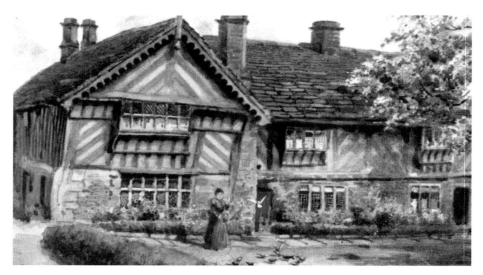

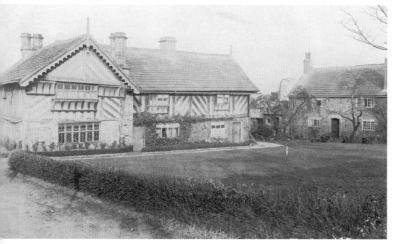

Above right: Bishop's House at Meersbrook, in a card of 1912. It is now a museum at Meersbrook Park, off Norton Lees Lane. This is one of Sheffield's few remaining timber-framed buildings and dates from the 1500s. It was named after the sons of William Blythe – John, Bishop of Salisbury and Geoffrey, Bishop of Coventry and Lichfield – and was bought in 1753 by William Shore.

Above left: This painting of Bishop's House, Meersbrook, was by E. Blore in 1823 and shows it as a working farm building with a haystack adjacent. The seated figures, a man and a woman, appear to be holding something, and the bent figure of a man is busy working with some long-handled wooden tool. A wicker basket is on the ground nearby and another long wooden shaft is sticking through the basket handle.

Below left: This photograph from the early twentieth century shows Bishop's House at Meersbrook with the cottages to the side, which have long since been demolished. William Blythe, the owner, was buried at Norton church and on a gravestone in the porch is inscribed the following: 'Here lieth the body of William Blythe of Norton Lees, who was buried here on 9 February, in the year 1665, being in the 57 year of his age.'

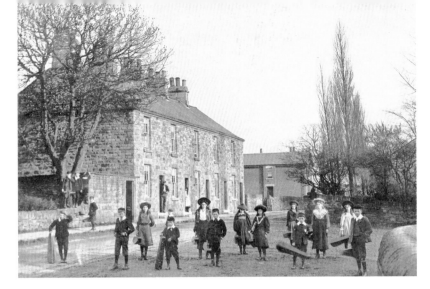

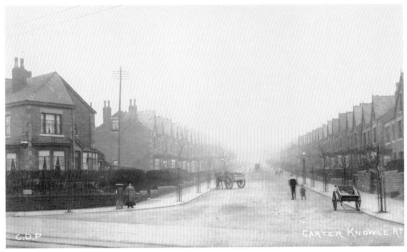

Above left: Greenhill and old cottages, portrayed in late Victorian times, and it looks like the entire violin section of the school orchestra has turned out. All the children are well dressed and sport caps or bonnets.

Above right: This photograph taken in the early 1900s shows Carter Knowle Road, with newly planted roadside trees, horse and cart, and a carriage in the distance. The small town of Sheffield rapidly expanded and, bursting at its seams, sprawled out into the surrounding countryside to subsume villages, hamlets and much more besides. Factories and transport systems spread along the valley bottoms and close by the rivers, and houses were built too. In the valley bottoms and close to the factories were poorer, basic terraces, and away, further up the hill, were more substantial, in this case semi-detached, properties. Note too the overcast smoggy pall over the area.

Below right: The suburban landscape of Crookes is shown in around 1849; the public house is still there.

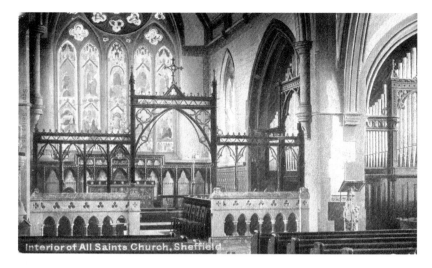

Interior of All Saints Church, Sheffield

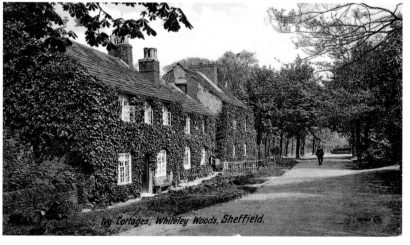

Ivy Cottages, Whiteley Woods, Sheffield.

Above left: This picture from the early 1900s shows the splendid interior of All Saints Church, Ringinglow Road, Ecclesall. This building dates from 1789, when it was consecrated by the archbishop, and replaced a smaller wooden structure used by the monks of Beauchief Abbey. The parsonage, constructed along with schools in 1834, was said to be one of the prettiest in England. The schools were rebuilt in 1861.

Above right: R. R. Pickford painted Highfields in around 1879, and it is difficult to reconcile this tranquil, verdant, rural image with the busy city street which replaced it only a few years later.

Below left: Ivy Cottages at Whiteley Woods, Sheffield, were a noted attraction for recreational visitors, and are pictured around the 1920s. As Sheffield expanded, the urban housing came into areas already long since used for waterpower and industry. As these peripheral works closed, probably unable to compete with the larger factories, the green areas of the Porter and Rivelin Valleys in particular became the leisure grounds of the urban middle classes.

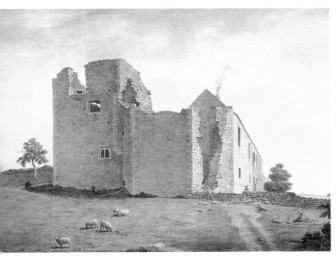

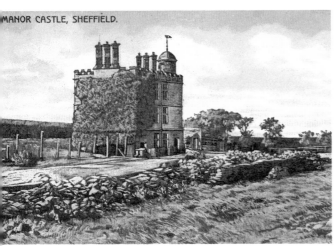

MANOR CASTLE, SHEFFIELD.

Above left: This 1818 painting by R. Hopkinson presents Sheffield Manor in a rather different light, the next picture of the Manor Lodge in the early 1900s looking more like a fortified building than the park mansion. The 4th Earl of Shrewsbury built the Manor Lodge as a country residence early in the 1500s. The park itself was massive undertaking around 8 miles in circumference, covering 2,500 acres and enclosing 'a thousand fallow deer and two hundred deer of antler'.

Below left: Manor Castle, or more correctly Manor Lodge, pictured around 1906 or slightly earlier and showing the site as a still working rural landscape. The park had long since gone but the land was still farmed, and coalmining and iron working proceeded cheek-by-jowl with agriculture.

Right: A photograph taken of the Manor Lodge in the early 1900s shows the building apparently still in use, but both smoke-stained and in part derelict. The lodge was used to hold a number of famous prisoners, including Cardinal Wolsey, who, on the orders of King Henry VIII, was held for eighteen days on his way to London, and Mary, Queen of Scots, who was held for fourteen years here in Sheffield Castle, or at Chatsworth; she was moved to and fro between the sites.

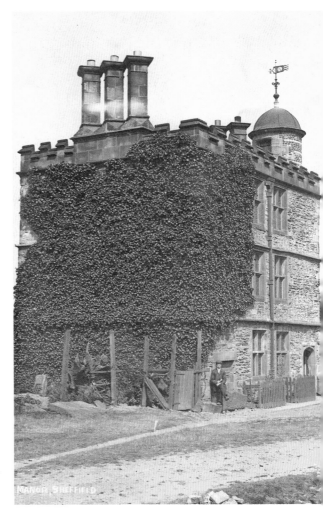

MANOR, SHEFFIELD.

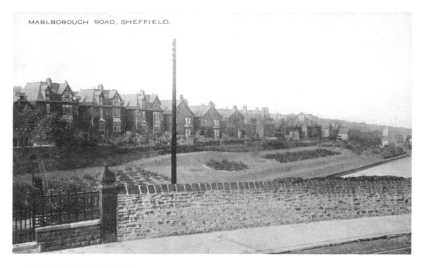

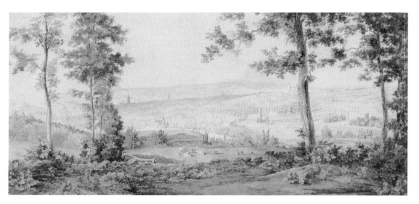

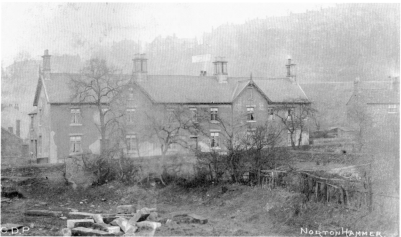

Above left: This view of the substantial Victorian properties of Marlborough Road, Broomhill, is from the early 1900s. Sheffield was expanding rapidly and needed clean water, hence the water supply reservoirs seen in the foreground, and the housing. The reservoir site is now the site of hard-surface sports pitches for Sheffield University.

Above right: In 1850, W. Ibbitt painted *North West View of Sheffield from Parkwood Spring.* Churches and factories are springing up across the once green landscape, and to the right of the picture the new hospital can be seen, the Royal Infirmary. Parkwood Spring should more correctly be Parkwood Springs, and was the ancient coppice wood of Hillsborough Park.

Below left: Under a shroud of heavy smog we see Norton Hammer in Edwardian times, and high above, the outlines of Victorian housing stand out around one of the major arterial routes to the south, Chesterfield Road. The tattered remains of an old hedge line and fencing probably indicate the recently rural nature of the area.

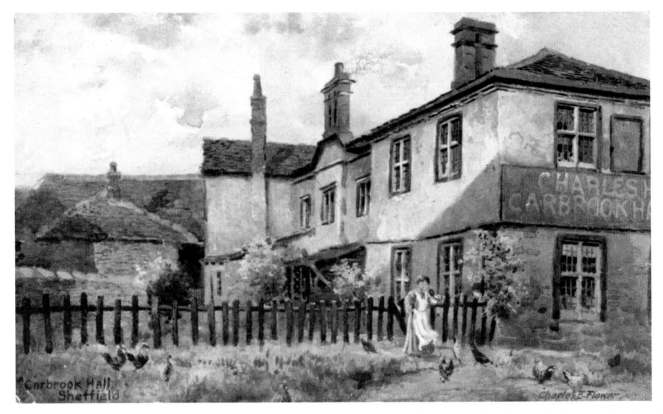

This evocative image of Old Carbrook Hall, Attercliffe, in the 1800s, captures a moment soon to disappear, with a lady at the farm feeding her chickens. The hall was located at the end of Attercliffe Common and was the home of the Blunt family as far back as 1176. Edward J. Vickers describes the hall being built in delightful surroundings with the clear waters of the River Don on one side and woodland and other rural features around it. The distant view was of the beautiful wooded slopes of Wincobank Hill. The hall was a fine family residence for many centuries, but by the late 1800s, having been a farm, it was now a 'common beer house'. The oldest parts of today's building probably date from around 1623.

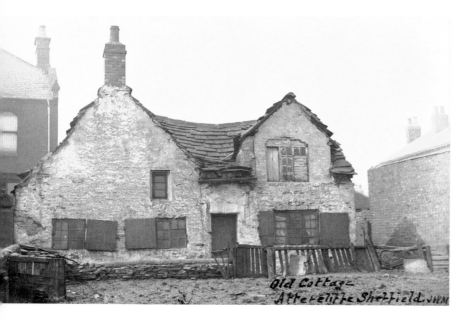

This remarkable photograph shows the old cottages at Attercliffe, again, like Carbrook Hall, a throwback to an older, rural landscape and community. The buildings are clearly dilapidated and by the 1970s, this was the site of the Employment Exchange in the heart of industrial Attercliffe.

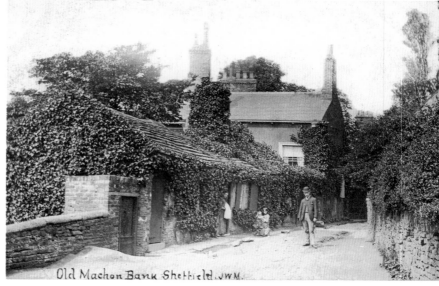

The photograph of Old Machin Bank is from the late 1800s or very early 1900s, and is a wonderfully evocative image of the time. What appears to be a family is posing for the picture, and the man is wearing a somewhat jauntily placed bowler hat. Along the wall up to the doorway there seems to be a small snowdrift, which does not fit with the leaves on the trees. The ivy on the buildings is evergreen, but still, the scene appears to be in summer. Maybe it was fine mud carried by a summer storm down this rather rough, unmetalled lane.

E. Price painted *Sheffield and the Valley of the Don* in 1863, and this shows the park of Parkwood Springs, however at this time split into large fields with grazing cattle. The expansion of Sheffield into Crookes, Walkley, and the Rivelin Valley is clearly visible, and in the distance, on the left-hand side of the image, a steam train is coming into view.

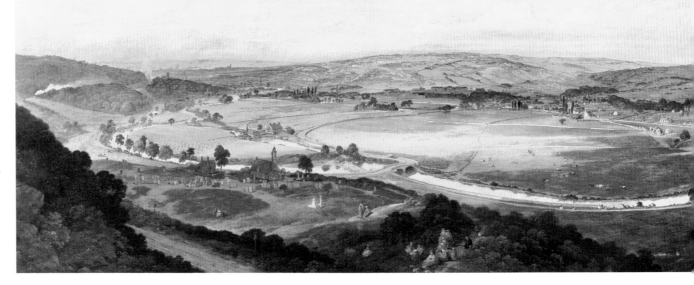

This view of *Sheffield from Broomhall Spring* was painted in 1791 by D. Martin, and shows a rural landscape on the edge of a small town. Fields are divided by stones walls, recently built, and in one case by a wooden paling fence. Workers toil in the fields and in the distance, substantial houses are visible, also perhaps the top of the Victorian old Town Hall and a major church.

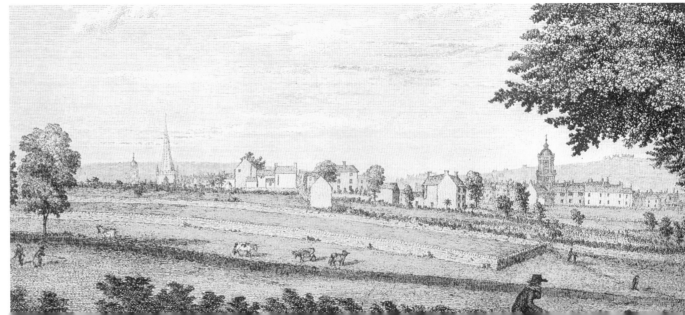

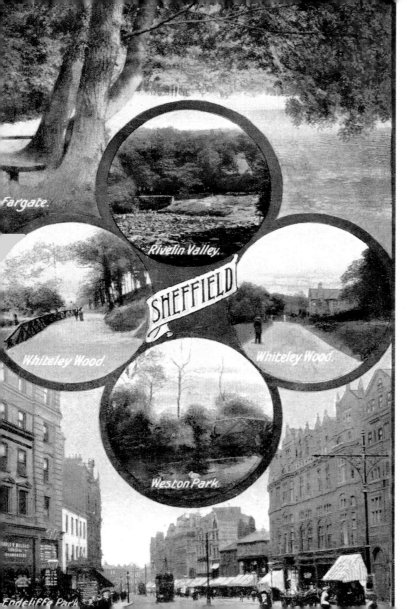

Left: I like this mixed panoramic view of Sheffield beauty spots, using pictures taken in Sheffield around the 1920s. Look carefully and find the mistake.

Below: A postcard sent in 1912 carries a picture of the rural Rivelin Valley of the time, but with the township of Lower Stannington in development and the gravestones of Walkley Cemetery just visible. Notice the factories with their smoke stacks and the smoke drifting eastwards in the prevailing westerly winds.

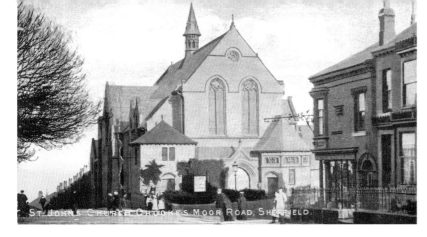

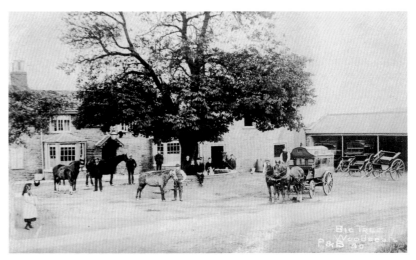

Above left: St John's Church, Crookes Moor Road, Crookes, is pictured in a card dated 1906. The recent urban expansion has almost entirely obliterated the moorland and the once small hamlets are absorbed into the swelling town, and now city, of Sheffield.

Above right: Here an undated photograph, probably Edwardian, shows 'The Big Tree' public house on Chesterfield Road, Woodseats, and the Woodseats horse-drawn bus and carriages. The site has had at least three 'big trees'; this one is a horse chestnut, and I think it was knocked down or pulled over by an elephant from a travelling circus – at least that's what I was told as a child. The pub was formerly called the Mason's Arms but was renamed in 1936, though this was after the original tree in front had been pulled down. In its place, a new tree was planted; this blew down in the 1980s and was replaced. There are masonic symbols inlaid into the floor that are now covered by carpets.

Below right: Sheffield had strong links with John Ruskin and this postcard shows the Ruskin Museum in Meersbrook Park in the early 1900s. This building once housed the substantial collections accrued by Ruskin and deposited in Sheffield for the public good. It then became, and remains, the head office of the City Council's Recreation Department, now called Leisure Services.

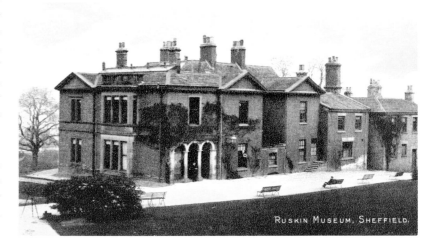

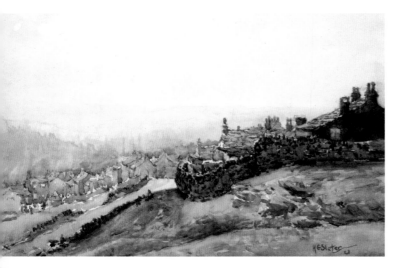

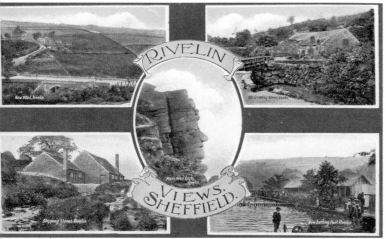

Above left: In 1931, Herbert Slater portrayed *Sheffield from Sky Edge, Park,* the name 'Park' by this time indicating the area and political ward that was once the great Manor Deer Park. Note the old cottages in the foreground, the ranks of Victorian and Edwardian housing spreading up the hill and the smog-laden valleys beyond.

Below left: These views around Rivelin Valley include the 'face in the rock' around 1910, and other scenic or recreational places. Notice the sheer number of people at the new bathing pool.

Right: A postcard of views around Edwardian Sheffield shows both urban and rural places to best advantage.

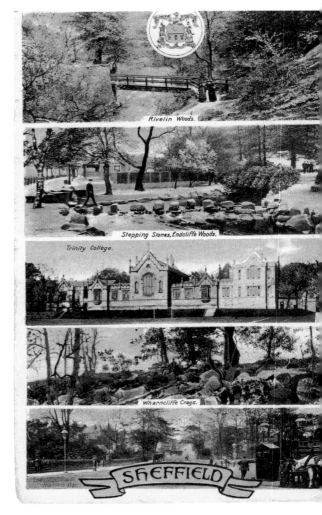

4

A CITY OF RIVERS

Sheffield grew firstly as a strategic crossing on the River Don, and then because of the use of waterpower across the region as the scores of small rural mills grew to manufacture the sharp tools for which the town became famous. A town of rivers and valleys, the roads followed the sinuous valleys or else strode along ridgeways on the higher ground. Over time, the roads were joined in the valleys by canals, railways, tramways and more. The rivers became arteries and sewers for the growing industry. Closed to public view, they died a slow and lingering death, but were reborn through community environmental action in the 1980s until the present day. Trout, otters, water voles, kingfishers, herons and even red deer are now regular wildlife sighted on the urban rivers.

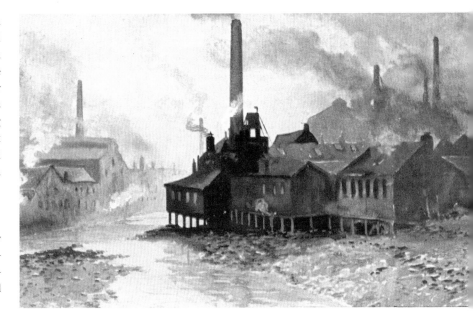

This image is from a postcard entitled 'A Sheffield Forge on the River Don', by Hayward-Young, in the early 1900s; the card was posted in 1907. Walter Hayward-Young (1868–1920) was a British artist educated at Warwick School. Hayward-Young's work, particularly his postcard designs (there were over 800), was world famous and was signed under the pseudonym 'Jotter'.

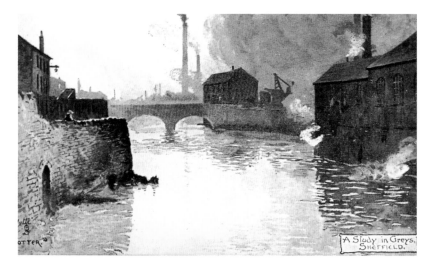

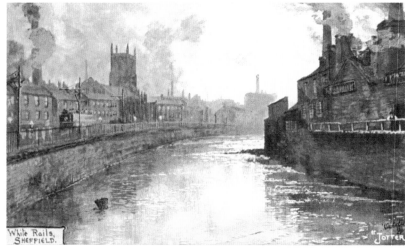

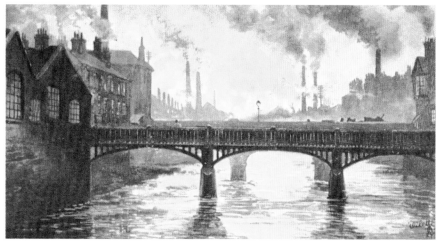

Above left: 'A Study in Greys' by Hayward-Young – the urban River Don around 1900.

Above right: 'White Rails, River Don, Sheffield' by Hayward-Young in the early 1900s.

Below left: 'Early Morning on the River Don, Sheffield' by Hayward-Young in the early 1900s.

Above right: 'Work-a-Day Sheffield' by Hayward-Young, showing the River Don and Blonk Bridge in the early 1900s.

Below right: This illustration is from a painting called *Fog, Steam and Smoke on the River Don*, and was done around 1909 by I. Pennell. It captures the awful pollution of the time.

Far right: 'River Don from Lady's Bridge' by Hayward-Young in the early 1900s.

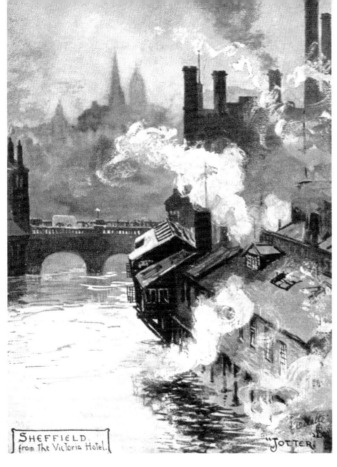

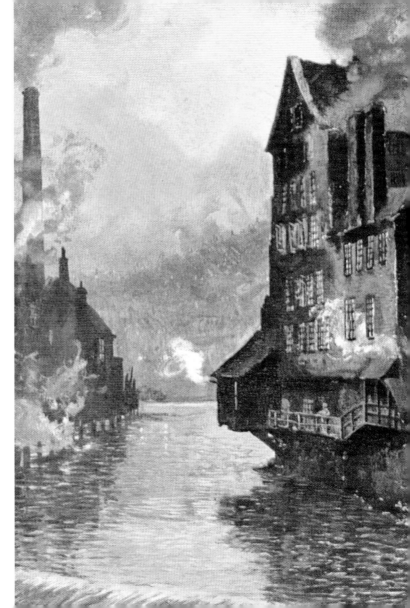

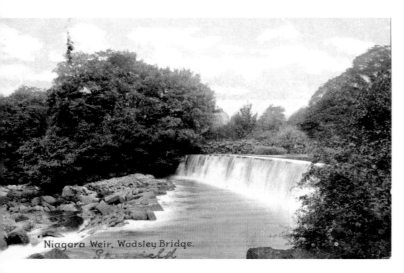

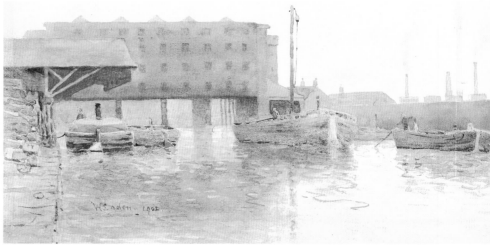

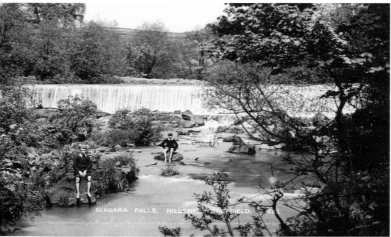

Above left: This is a splendid photograph of the Niagara Weir on the River Don at Wadsley Bridge, near Hillsborough, on a card posted in 1909. The large leaves of Butterbur, nowadays rather uncommon on the River Don, are visible on the far side of the river. The broken stonework of a once extensive causeway is exposed below the waterfall. Along with the gross water pollution, it was the series of water-power and water-supply weirs that stopped the salmon coming upstream.

Above right: With its many rivers, Sheffield has only one major canal. This painting by W. Boden shows *Sheffield Canal Basin* around 1902.

Below left: This beautiful photograph shows the River Don at Niagara Falls, Hillsborough, Sheffield. It is probably in the 1930s and the two boys are clearly enjoying a paddle and maybe fishing in the river. Within a few decades, paddling here would surely have been unthinkable because of the debris and litter, and the horrendous pollution.

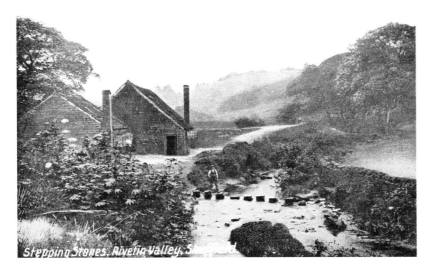

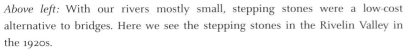

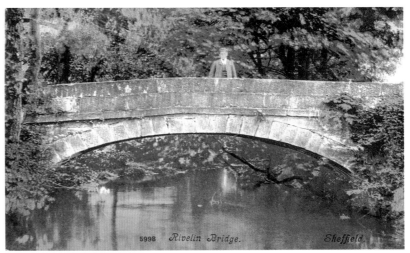

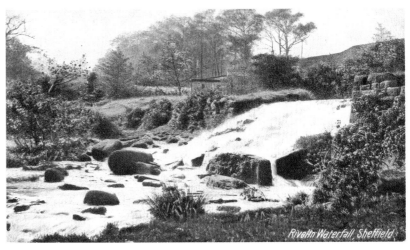

Above left: With our rivers mostly small, stepping stones were a low-cost alternative to bridges. Here we see the stepping stones in the Rivelin Valley in the 1920s.

Above right: A card posted in 1904 shows Rivelin Bridge in the Rivelin Valley, one of Sheffield's arterial waterways. It part of was the series of generally small rivers that powered the early industry, and along which the small water mills and associated works sprang up.

Below right: The picture presents a Rivelin waterfall near an old watermill in the early 1900s. The roof of the mill is just visible and the scene was typical of many across the city.

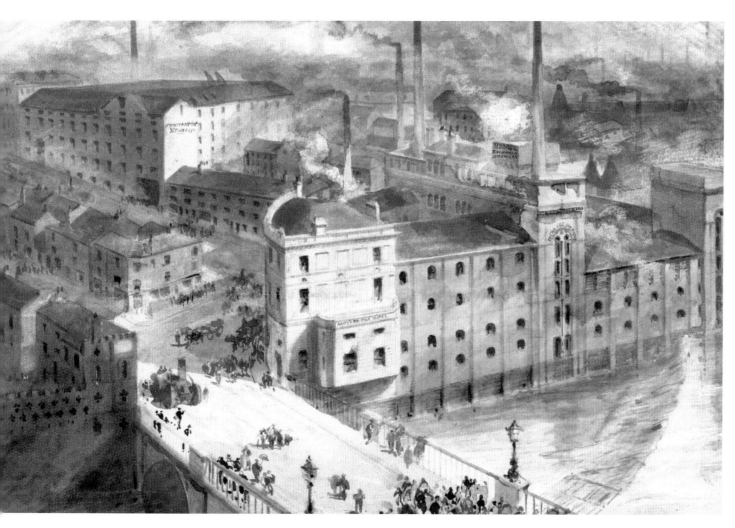

With the medieval bridge now hidden under the more modern structures, an unknown artist has portrayed *Sheffield from Lady's Bridge* in around 1900. The site of the derelict castle was nearby, but by then was being built over.

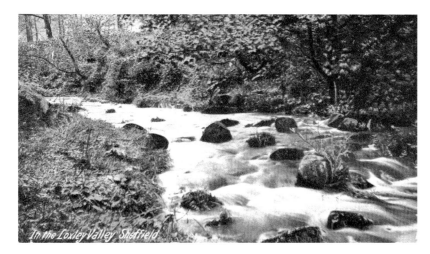

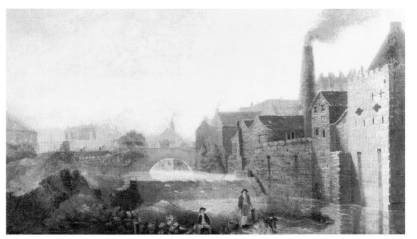

Above left: The River Loxley, Sheffield, is shown in the early 1900s. The waterpower drove the Industrial Revolution, and the industrial archaeology here and in Rivelin is some of the most complete in Europe for this type of metalworking and refractory industry. In the 1980s, it was being compared to Ironbridge in the West Midlands, though the latter is a more unified and compact development, and is more amenable to major tourism development.

Above right: The River Sheaf and the Shrewsbury Hospital are shown in an anonymous painting in 1825. The image shows a factory at work, a major weir, and a stone bridge.

Below right: I. Rowan painted Tinsley Lock in the Lower Don Valley in around 1890, with a view that is strongly rural in character and very hard to imagine today. This is close by the M1 motorway, Meadowhall, and Blackburn Meadows sewage treatment works.

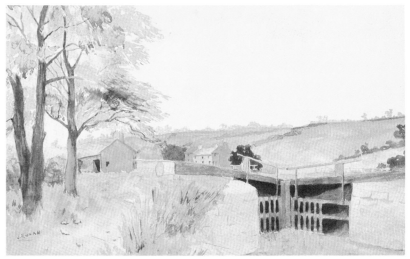

PEOPLE AND PLACES

Sheffield people are generally quite distinctive and mostly friendly, if perhaps somewhat judgemental. They are welcoming to strangers and familiar in ways that those from other areas may find surprising; the bus drivers' welcomes of 'love', for example, still amuse and perplex visitors in equal amounts. Sheffielders are also immensely proud of their city, even in the depths of adversities such as the Blitz, the Depression, or a recession. Over the centuries, the city has grown to be a centre for work and play, festivals and events, sports and pastimes.

A city like Sheffield boasts a diversity of people and entertainments, such as Sheffield's own award-winning Barbershop Harmony Club in the early 1990s.

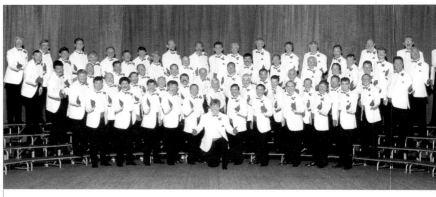

Sheffield Barbershop Harmony Club

"Hallmark of Harmony"

P.R.O.
MARTIN HILL, 40 ACACIA CRESCENT
KILLAMARSH, SHEFFIELD S31 8HZ
TELEPHONE AND FAX:
SHEFFIELD 484664

EMI Recording Artists
1986 British Chorus Champions
1988 'Sainsbury's Choir of the Year' Finalists
1989 British Chorus Champions
1991 British Chorus Champions

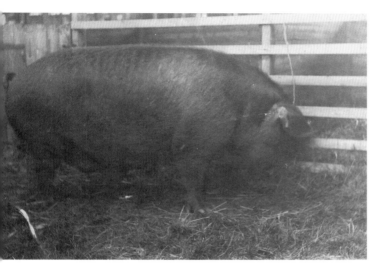

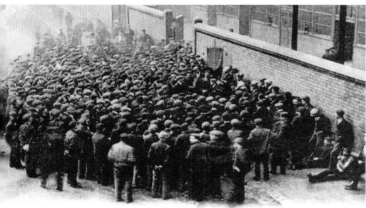

Dinner Hour Meeting of the Open Air Mission at the East Hecla Steel Works, Sheffield.

Above left: With its reputation for industry, Sheffield's other activities are frequently forgotten or overlooked. Here we see the Champion Pig at the Great Yorkshire Show held in Sheffield. It weighed 9 hundredweights, 3 stones and 4 pounds, and was sold for 500 guineas. Fifteen piglets were sold at an average of £178-17-0. This was probably in the early 1900s.

Below left: Sheffield, like all the big emerging industrial cities, was a centre for religious activities and especially for Nonconformism. This picture shows a dinner-hour meeting of the Open Air Mission at the East Hecla Steelworks, Sheffield, probably in the 1920s.

Right: Any Port in a Storm was from the original oil painting to be seen at 'George Greenfield's Midland Hotel, Spital Hill, Sheffield, Yorks', and was probably Edwardian.

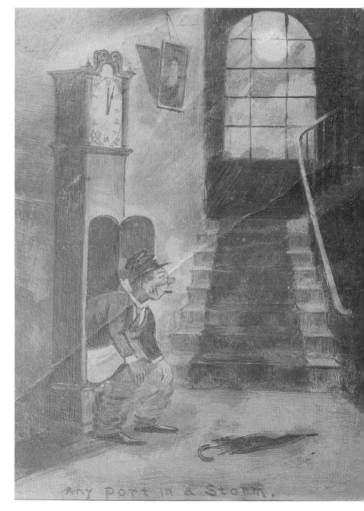

Any Port in a Storm.

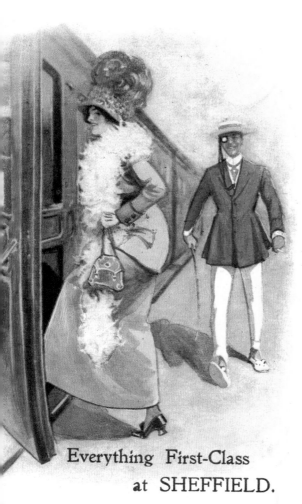

Everything First-Class
at SHEFFIELD.

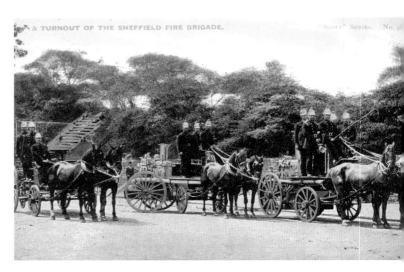

A TURNOUT OF THE SHEFFIELD FIRE BRIGADE. "SCOTT" SERIES. No. 3.

Above right: Medieval towns, with their thatched roofs and wooden-frame buildings, were especially prone to fire and singularly ill-equipped to deal with it. However, the emerging industrial towns and cities, particularly those with factory premises, were also at major risk. The response was to establish a properly trained and resourced fire service, and here we see a turnout of the Sheffield Fire Brigade around 1907.

Below right: A pilot is shown flying a plane with a leather despatch case with 'Greetings from Sheffield'. The card is probably from the 1900s and may be in wartime, and the case opens to reveal pictures of the city.

Left: An obviously first-class couple are shown in this card, 'Everything First-Class at Sheffield', which is probably from the early 1900s.

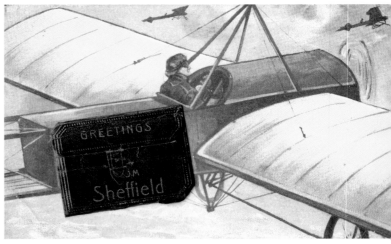

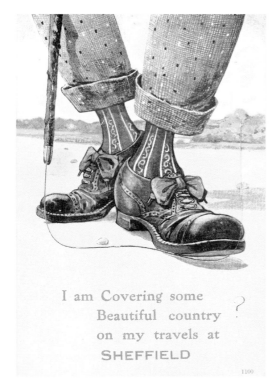

Above left: A humorous postcard was inscribed with the message, 'A bit of smoky Sheffield' and posted to West Manchester, New HampshIre, USA, in May 1913. On the front, it says, 'I am covering some Beautiful country on my travels at Sheffield.'

Above middle: This card gives a humorous view of visitor accommodation in Sheffield around 1908. A man sits in a tiny, grubby room with cobwebs, and the writing states, 'I Got Splendid Furnished Apartments at Sheffield.'

Above right: The card is a typical romantic image of the time; 'Just a line from Sheffield' in 1914.

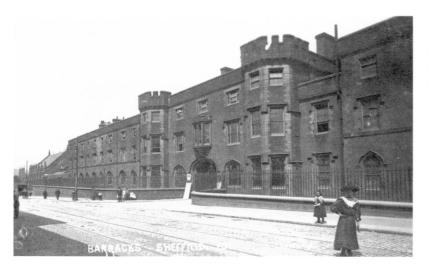

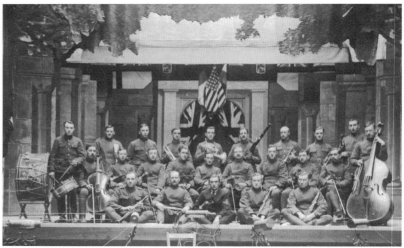

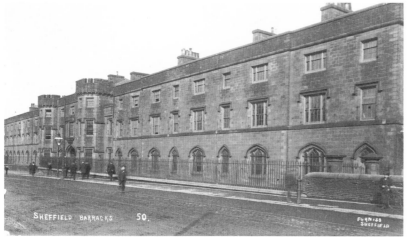

Above left: The Sheffield Barracks at Hillsborough are pictured around 1914–18. The site is now a shopping precinct, but the main structures have been retained.

Above right: This photograph is of the orchestra of the RAF Northern Area Repair Depot pictured in 1918 or 1919. They were based at Norton and this is possibly an Armistice concert.

Below left: This picture shows the Sheffield Barracks, Hillsborough, in 1916, and was sent from MQ 22 D-Block to a Miss Elsie Hurst to let her know that all was well and the sender had arrived safely. With cards such as this, you always wonder what the eventual outcome was.

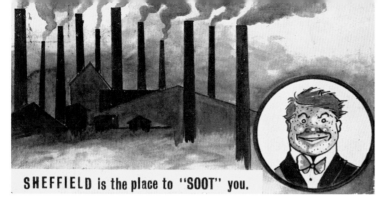

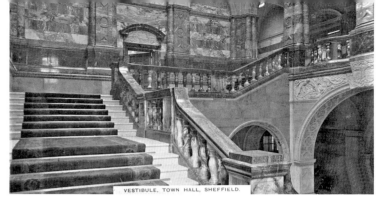

Above left: The dirty industrial city is celebrated in this witty card entitled 'Sheffield is the place to soot you', posted in 1911.

Above right: Entrance to Sheffield Town Hall for most visitors and certainly for formal events is via the vestibule and grand staircase, as shown in 1910.

Below left: It is easy to forget how big a hobby the keeping of cage birds was in cities and towns like Victorian and Edwardian Sheffield. The Sheffield Ornithological Society open show was on 1 and 2 November, and this is probably around 1910.

Below right: No so many people see and experience the inside of Sheffield Town Hall as the millions who see the outside. Visitors might find themselves at a formal event in the reception room, pictured here around 1909.

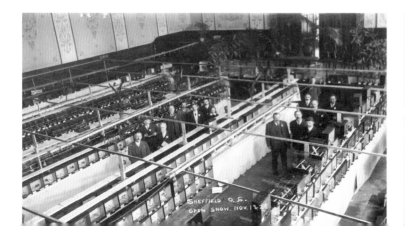

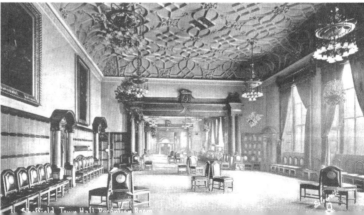

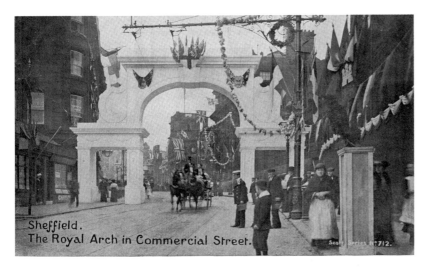

Sheffield.
The Royal Arch in Commercial Street.

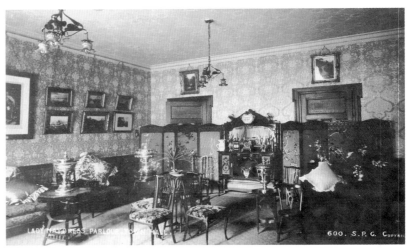

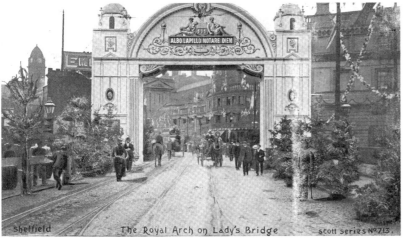

Sheffield The Royal Arch on Lady's Bridge scott series Nº713.

Above left: By the time Sheffield was a city, a royal visit demanded a demonstration of corporate splendour to match the occasion. The route for the royal party was often decorated by grand, albeit temporary, arches. This is the Royal Arch in Commercial Street for the royal visit in 1905. Some, such as the Wicker Arches, were substantial, permanent structures.

Above right: The Town Hall was and is a warren of a building with a vast number of rooms, from grand halls to tiny offices once occupied by town clerks. This is the Lady Mayoress's Parlour, Sheffield Town Hall, around 1910.

Below left: The picture shows the Royal Arch on Lady's Bridge, in 1905.

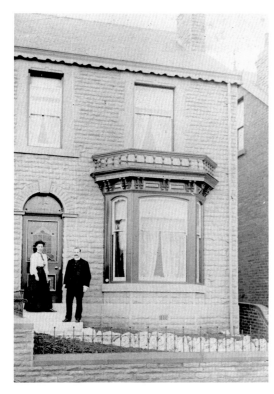
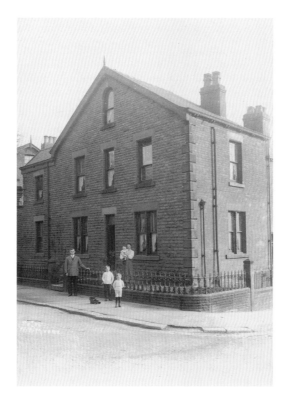
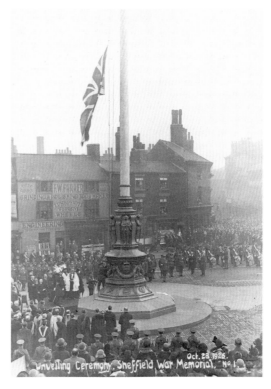

Above left: The photograph shows the proud owners of a substantial Sheffield house at Walkley in 1908. The property still has the wrought-iron fencing in the front wall. Most of these were taken during the Second World War, supposedly to build Spitfires, but in reality it was a morale-building publicity stunt.

Above middle: The photograph shows typical Victorian-built workers' housing in 1914, in perhaps Walkley or Woodseats.

Above right: This picture shows the unveiling of the Sheffield War Memorial, on 28 October 1925 in Barker's Pool. The unveiling was by Lt-Gen. Sir Charles H. Harington, G.B.E., K.C.B., D.S.O.

PARKS AND GARDENS

From Victorian parks to botanical gardens, from libraries and museums to art galleries and theatres, the emerging city prided itself on providing the best possible. This past investment has provided the Sheffield of today with a remarkable and wonderful heritage of both open green spaces and cultural facilities. It is only today that these resources are threatened by lack of vision and punitive political cuts in the cultural fabric of the city. Throughout the dirty, growing city, the Victorians provided extensive parks and gardens, most of which were public, with just a few by private subscription.

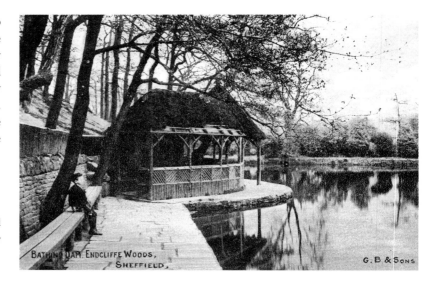

Many of the city's parks had features such as this shelter, perhaps with a thatched roof. This one is at the Bathing Dam, Endcliffe Woods, Sheffield, in the early 1900s.

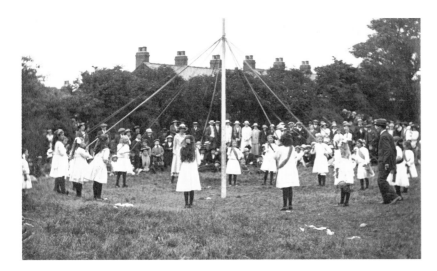

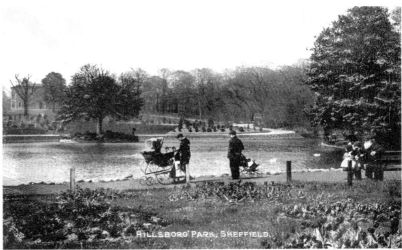

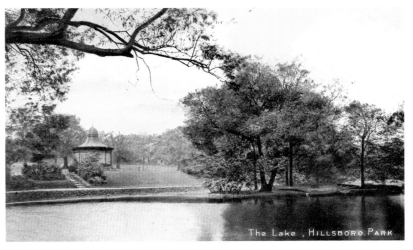

Above left: Urban parks are always centres for activities and recreational events, in this case a maypole dance in Hillsborough Park in 1921.

Above right: This postcard from the early 1900s shows a scene in Edwardian Hillsborough Park, with a man, children and a pram, and an older gentleman with a magnificent white beard. A big house is visible in the far distance.

Below right: The lake, Hillsborough Park is pictured on a card posted in 1907. The glazed bandstand or pavilion, a typical Victorian park feature, is shown in the distance.

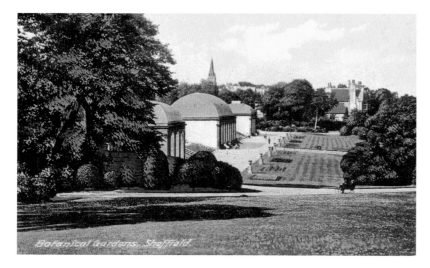

Botanical Gardens, Sheffield.

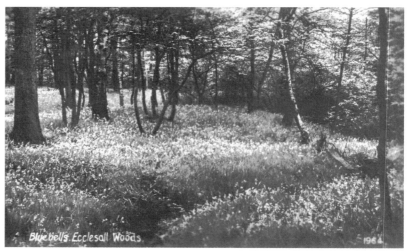

Bluebells, Ecclesall Woods.

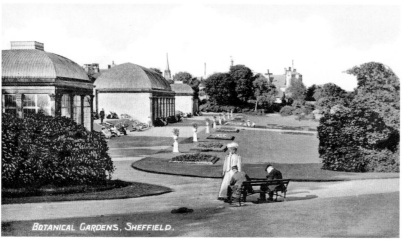

BOTANICAL GARDENS, SHEFFIELD.

Above left: This card in the early 1900s shows the Sheffield Botanical Gardens, with their neatly trimmed and manicured beds and their meticulously mown lawns.

Above right: Despite extensive searching, I have found very few early pictures of Ecclesall Woods. This photograph shows bluebells in Ecclesall Woods in 1964.

Below left: Another image of the Edwardian Sheffield Botanical Gardens shows the three pavilions in 1910, with rather splendidly dressed visitors.

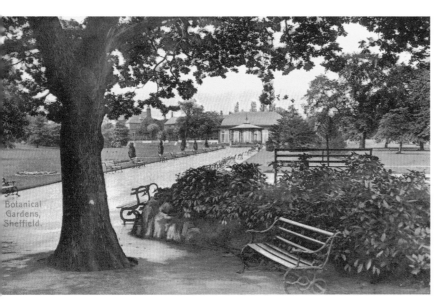

This is a particularly interesting view of the Sheffield Botanical Gardens, as it shows just a single pavilion, probably early 1900s. There is a typical park bench and the view is looking up towards the bandstand.

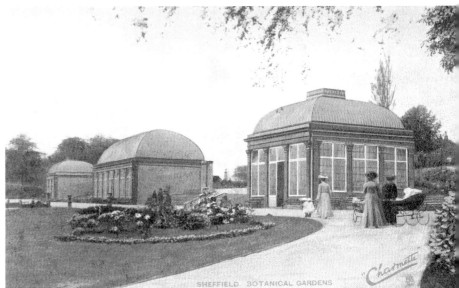

Sheffield Botanical Gardens with the three pavilions pictured in the early 1900s, showing the glasshouses but nothing in between them.

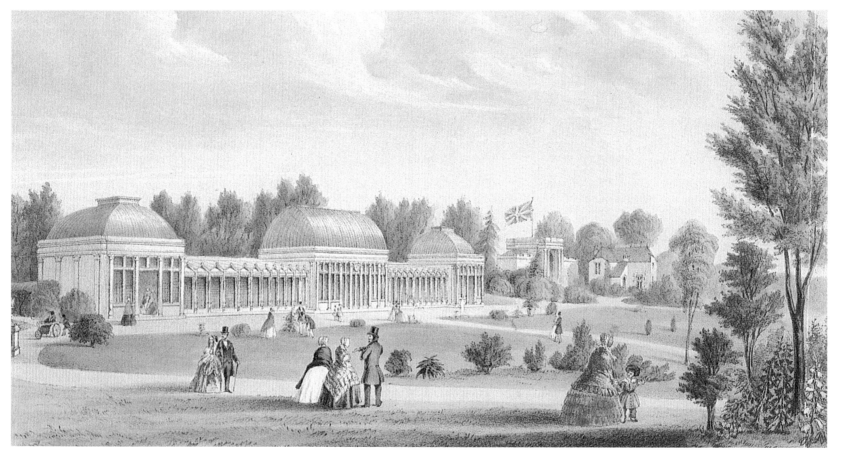

Sheffield Botanical Gardens are pictured around 1850 in a painting by I. Shaw. The presence or absence of the glasshouses and the linking sections in pictures of different dates is puzzling, particularly as some later images seem to show the gardens without. The Union Jack flies patriotically over the entrance lodge and a person in a bath chair is being pushed along the top path.

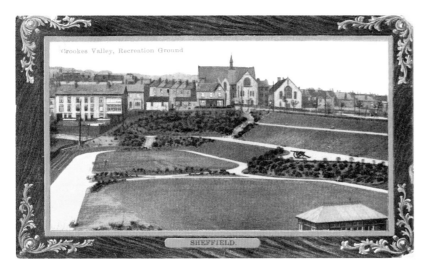

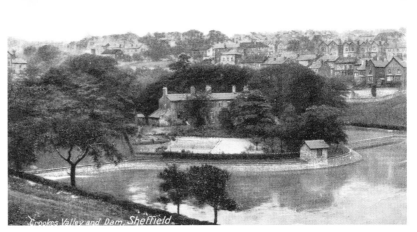

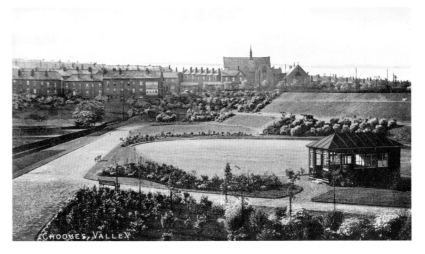

Above left: Now, by around 1910, the Crookes Valley Recreation Ground near the present-day Sheffield University has new landscaping and one lake has been infilled and grassed over.

Above right: The need for a water supply for the growing town led to a number of small reservoirs to the west of Sheffield. The one at this site became Crookes Valley Park and dam, as shown here in 1908.

Below right: Not obvious today, the site is split into two separate lakes. This card of Crookes Valley Park, showing the Victorian housing, was posted in 1902.

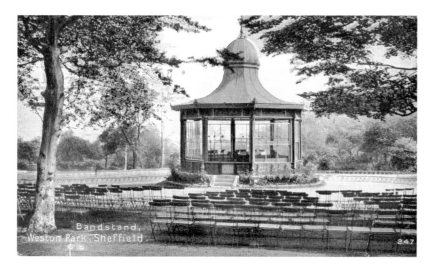

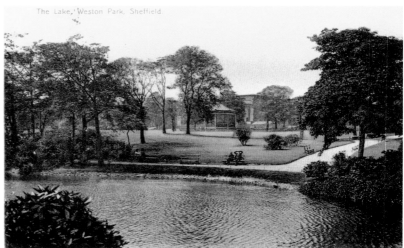

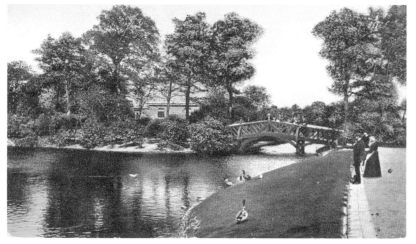

Above left: This wonderful image shows the Edwardian bandstand at Weston Park with a good number of seats set for an obviously popular event.

Above right: The lake at Weston Park, next to Sheffield University, is illustrated in around 1905, with a view back toward the Mappin Galley and Weston Park Museum.

Below left: Edwardian Weston Park is shown with the ornamental duck pond and the ornate wooden bridge.

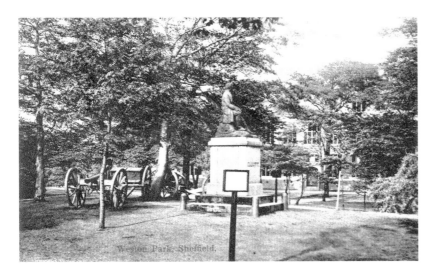

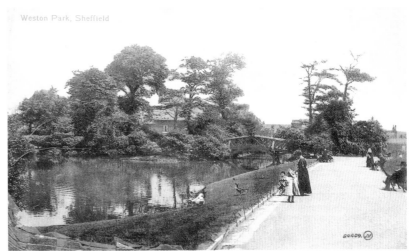

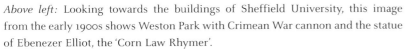

Above left: Looking towards the buildings of Sheffield University, this image from the early 1900s shows Weston Park with Crimean War cannon and the statue of Ebenezer Elliot, the 'Corn Law Rhymer'.

Above right: This is another view of Weston Park and the ornamental pond in the early 1900s. It shows the ageless practice of small children feeding the ducks.

Below right: These are the famous Weston Park wrought-iron gates, in the early 1900s. These were infamously stolen in September 1994, but found and returned a few years ago.

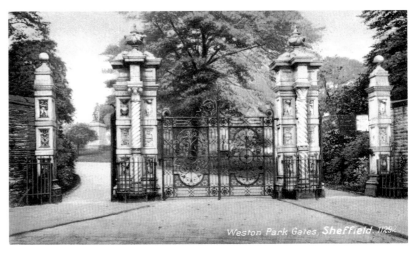

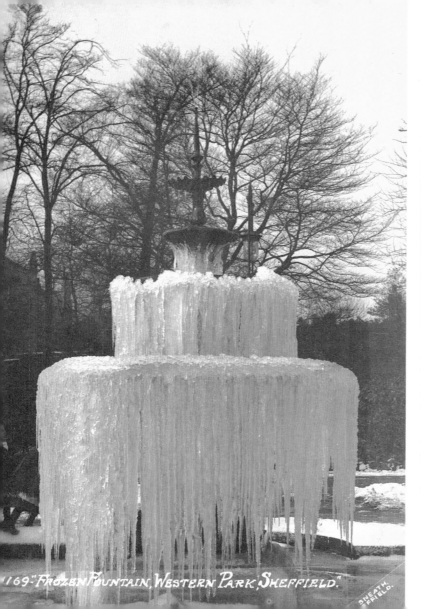

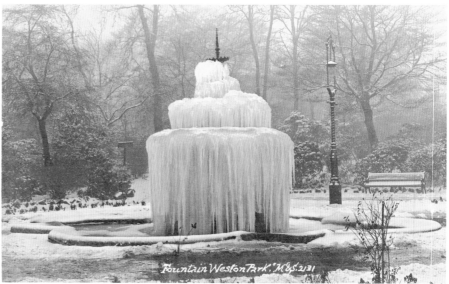

Above: The frozen fountain at Weston Park was a popular image of early postcards and was from 1911, when there was a period of intense cold between December and February. July to September 1911 was surprisingly hot, with twenty days over 26.7 °C, and peaking at over 33 °C.

Left: This image shows the frozen fountain at Weston Park, but if you compare the two pictures, it is clearly after a bit of a thaw.

Opposite: Weston Park in around 1910 by A. Wilson.

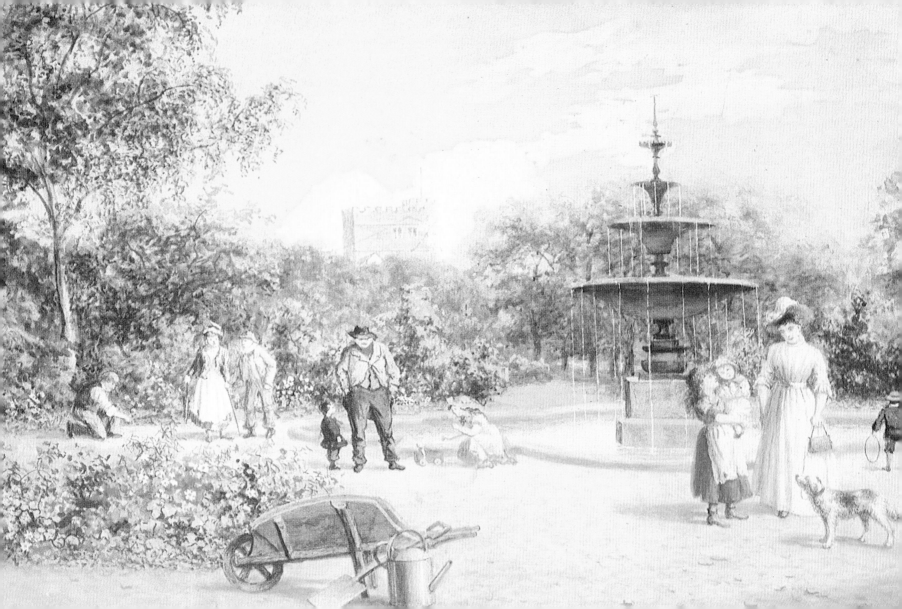

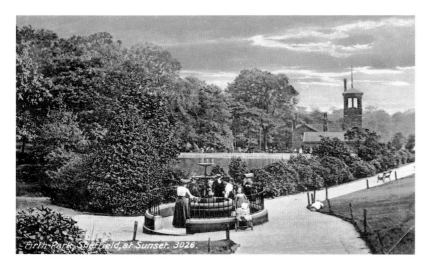

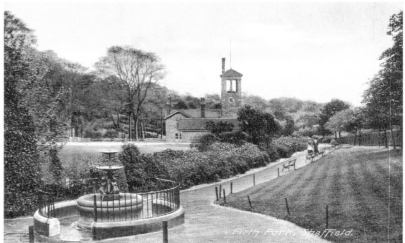

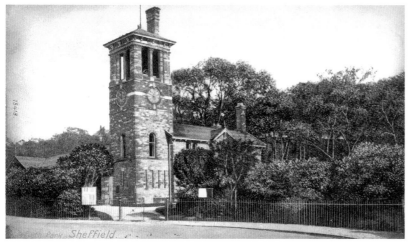

Above left: Firth Park is shown with an Edwardian family at the drinking fountain. Mark Firth wanted to create an environment with quality housing, leisure and greenery for his workers and their families. This was a similar concept to that of the Bournville project close to industrial Birmingham.

Above right: One of the grand Victorian parks of the expanding city was Firth Park, shown here as the Edwardian park with its ornamental fountain. Opened by the Prince of Wales HRH Prince Albert Edward, later Edward VII, the park was given to Sheffield in 1875 by Mark Firth, who was the owner of a number of Sheffield steelworks. His portfolio included the well-known company of that time, Firth Brown.

Below left: The Clock Tower Pavilion at Firth Park is pictured on a card posted in 1906. The park was originally part of the Page Hall Estate before it was given as a gift to the people of Sheffield.

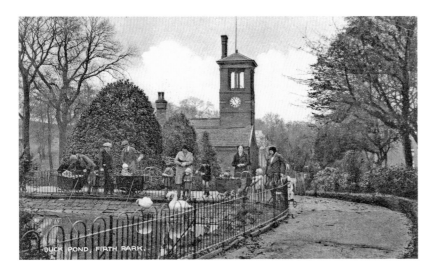

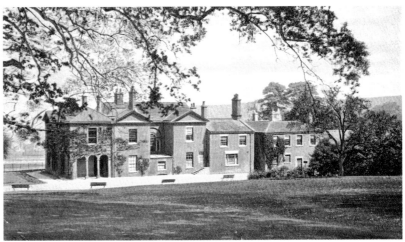

Above left: Firth Park duck pond is illustrated on a cold winter's day, with families feeding the mute swans.

Above right: Meersbrook Park is shown here in 1929, looking up the steep slope, which was, when I was young, the best sledging slope in the city. The area had previously been described as having the most beautiful glades outside Chatsworth Park. That was before the developers arrived.

Below right: This large house at the centre of the old Meersbrook Park is complete with a splendid walled garden, now restored. For a while, the building pictured on this card posted in 1906 housed the Ruskin Museum collection, and was locally called the Ruskin Museum.

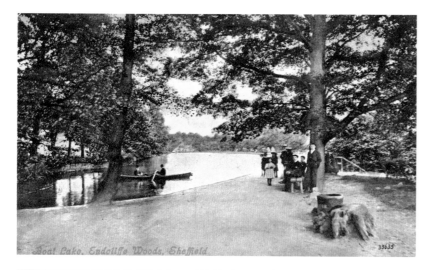

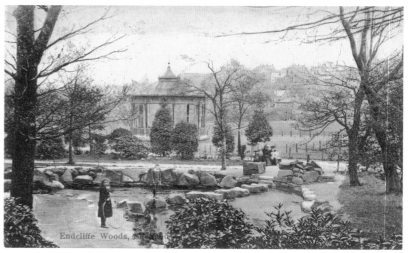

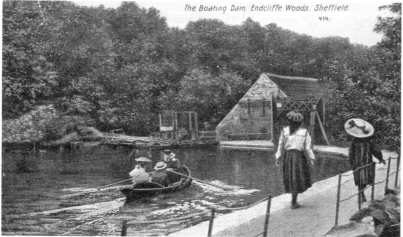

Above left: On the boating lake in Endcliffe Park, in the early 1900s. Notice the smart dress – even the rowers are wearing hats and the men have gleaming white collars to their shirts.

Above right: This picture shows Endcliffe Park and woods, and a girl with a hoop and a smartly dressed boy on the stepping stones. The card was posted in 1905. The bandstand is seen in the middle ground and the houses above Hunter's Bar form the background.

Below left: Edwardian Sheffielders are enjoying the delights of the Endcliffe Park boating dam, the men in caps or straw boaters and the women and girls in magnificent headwear.

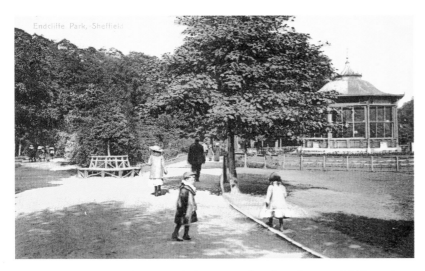

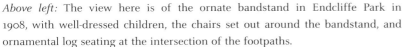

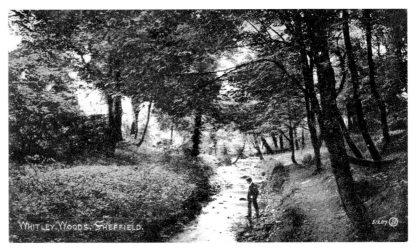

Above left: The view here is of the ornate bandstand in Endcliffe Park in 1908, with well-dressed children, the chairs set out around the bandstand, and ornamental log seating at the intersection of the footpaths.

Above right: The Lovers Bridge is shown in this picture of Whiteley Woods, just up the Porter Valley from Endcliffe Park. The scene is complete with Edwardian lady with her ostrich feather hat, and a little girl in what might be described as an oversized baby costume.

Below right: Whitely Woods is pictured in a card sent in 1907. As the brook is tracked upstream the landscape becomes more wooded in the valley bottom, and runs through open countryside rather than the urban setting of Endcliffe. Here we see a smartly dressed man or boy striding across the brook.

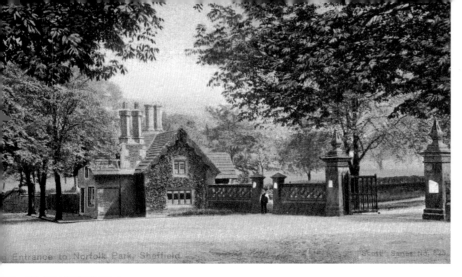

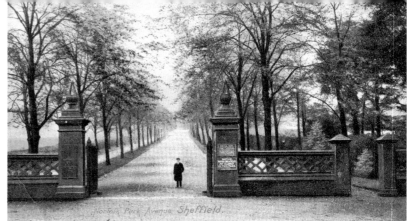

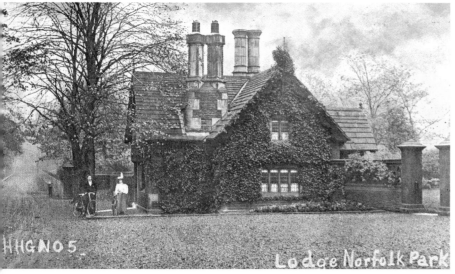

Above left: The image here is of the entrance and lodge at Norfolk Park, in the early 1900s. By the smaller gate entrance, a man in a suit and waistcoat is posing. I wonder if he was the park keeper. In 1956, Jervis Lum Wood on the west of the park was compulsorily purchased from the Duke of Norfolk and added to the park.

Above right: Norfolk Park is a grand Victorian recreational park and, in keeping with its status, the site boasts park lodges and impressive gateways. This card shows the grand entrance to Norfolk Park around 1907. It is on Norfolk Park Avenue, and bears a sign stating that it permits no motorcars and no bicycles. When it opened it was one of the first parks in Britain to be free to the general public. Queen Victoria visited on 21 May 1897, in her Jubilee year. Patriotic songs and hymns were sung by 50,000 schoolchildren and 200,000 people gathered in the park to see her.

Below left: In this picture we see the Park Lodge at Norfolk Park and an Edwardian couple on pedal bikes. Notice how the ivy on the building has spread since the photograph was taken for the earlier picture. Norfolk Park opened to the public in 1848, with work laying out the park having commenced in 1841 initiated by landowner, the 12th Duke of Norfolk.

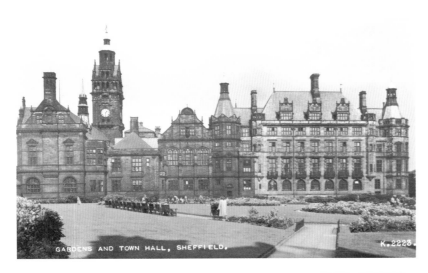

GARDENS AND TOWN HALL, SHEFFIELD. K.2223.

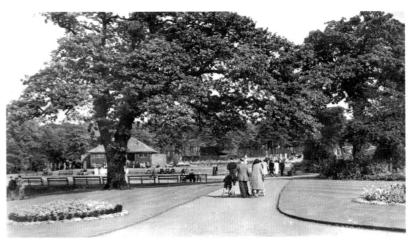

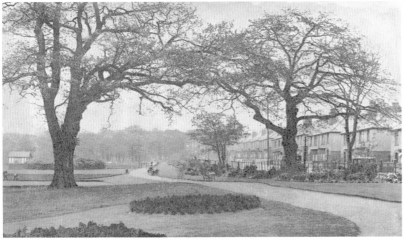

Above left: Public Open Spaces extended into the very heart of the city. The picture is of Sheffield Town Hall and the Peace Gardens. It is the early 1950s and the Town Hall still shows the grime and dirt of the grubby and polluted air.

Above right: A gift from Alderman J. G. Graves, Graves Park – though more correctly Norton Park – at Norton is Sheffield's largest public open space. It is pictured here in 1962 at the Chesterfield Road end. The big trees are oaks and probably were originally lane-side trees before the time of the modern park.

Below left: Graves Park is shown probably in the early 1930s or 1940s as the 1920–30s housing is well established and the car on the roadside is of that era. Again, this is at the Chesterfield Road end of the park. Alderman J. G. Graves acquired the park for Sheffield between 1926 and 1936, in order to protect the parkland and ancient woodland from building development. Mr Graves donated the 91.9-hectare park to the city.

High Hazels Park is another open space in south-east Sheffield and pictured here in around 1906. High Hazels Park was built in 1850 for William Jeffcock, the first Lord Mayor of Sheffield. Then, in 1894, Sheffield City Council (at that time the Corporation of Sheffield), purchased the park and house from the Duke of Norfolk and Messers Jeffcock for £10,875. In 1895, the land was a public recreation ground and one of the finest parks in Sheffield, boasting a fine boating lake. This lake has since been covered over.

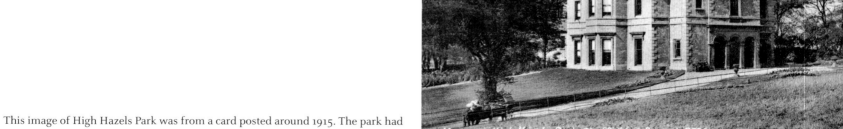

This image of High Hazels Park was from a card posted around 1915. The park had walks, ponds and a large house.

EDUCATION, HEALTH AND THE ARTS

As the city grew, so did the need for education and improvement, and especially the need for specialist skills, training and research relating to the industries that were driving Sheffield's industrial revolution. Schools, colleges, universities, libraries and art galleries all flourished. With a growing population came an increasing need for health care and hospitals. In wartime, the city provided specialist hospitals for the wounded and the recuperating.

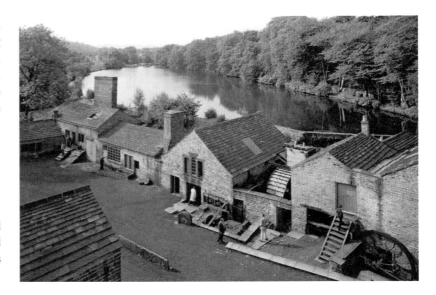

Sheffield boasts numerous museums and galleries, and the Abbeydale Industrial Hamlet Museum, shown here in the 1970s, was one of the first industrial museums in Britain. Now run by an independent charitable trust, the museum is still enormously popular.

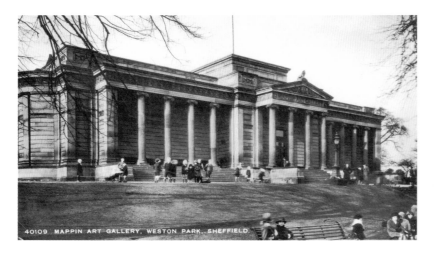

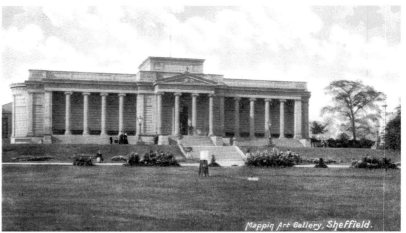

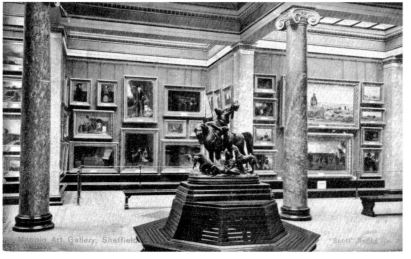

Above left: As a popular educational facility, the Mappin Art Gallery and the associated museum at Weston Park have always received great numbers of schoolchildren. Here in around 1935 children are swarming around the front of the building and the old-fashioned gas lamp at the top of the steps. The park bench in the foreground is typical of those still in use today.

Above right: One of the best-known public buildings in Sheffield is Mappin Art Gallery in Weston Park, shown here around 1907. Now under the administration of the Museums' Trust, the building includes the art gallery and the Weston Park Museum.

Below left: The recent major refurbishment has completely altered the interior of the building, but this image, from around 1905, gives a flavour of how it once was. Inside the Mappin Art Gallery in 1905, the walls are packed with paintings of Sheffield and collections of great significance to the city, and the building is opulent, with marble columns.

Sheffield University is pictured in the early 1900s, a typical view showing the old buildings next to Weston Park.

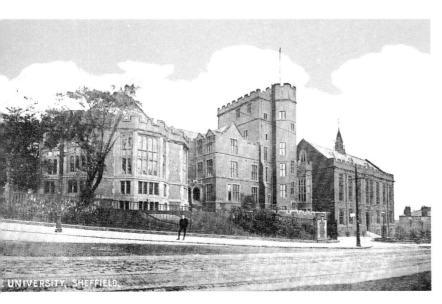

UNIVERSITY, SHEFFIELD.

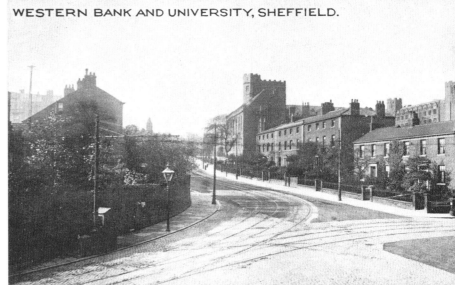

WESTERN BANK AND UNIVERSITY, SHEFFIELD.

Sheffield University is shown in the early 1900s with the tramlines and gas lamps of Western Bank. Victorian houses line the road where the modern Arts Tower car park is situated along with the various science faculty buildings. In the distance is a very imposing building with crenellated towers that has long since gone.

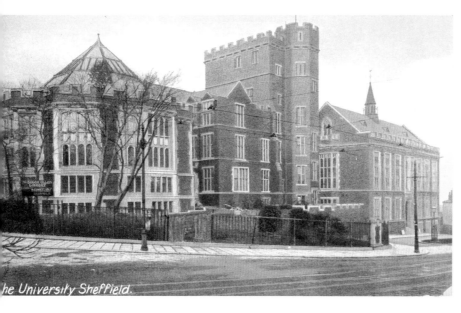

This photograph of the University of Sheffield was taken around the turn of the century in the early 1900s. It shows the then Edgar Allan Library.

Opposite: This picture of the University of Sheffield in the early 1970s shows the newly extended Biological Sciences buildings. The cars may bring back a few memories too.

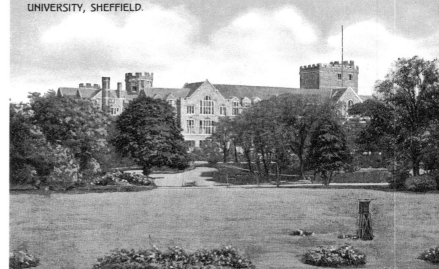

The University of Sheffield seen from Weston Park in the early 1900s. Note the famous weather gauge in the foreground, Sheffield Museum at Weston Park having one of the longest-running meteorological records in the country.

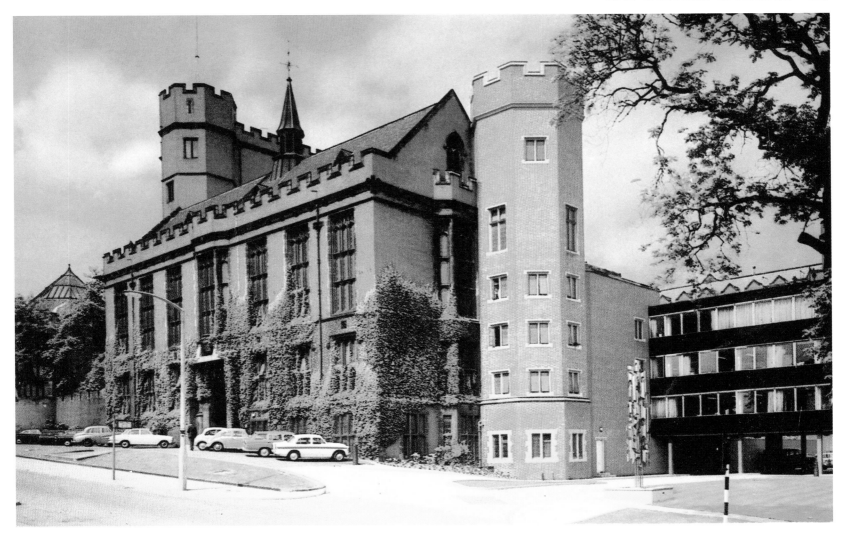

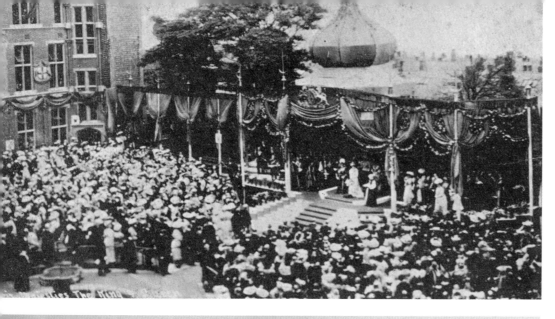

In 1905, Sheffield University came into being as a constituted, independent body. The photograph commemorates the visit of king and queen to Sheffield University on 12 July 1905, to grant it its own charter.

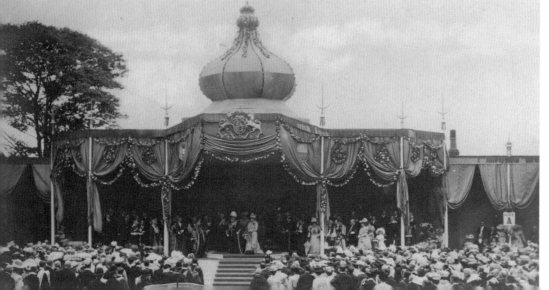

A second photograph of the royal visit to Sheffield University on 12 July 1905 captures the grandeur of the occasion. The university's chancellor is asking His Majesty to declare the university open.

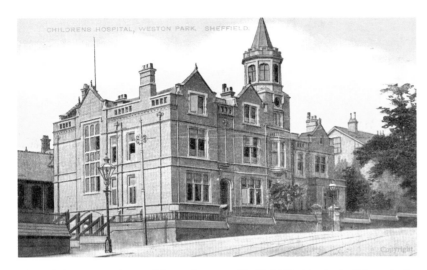

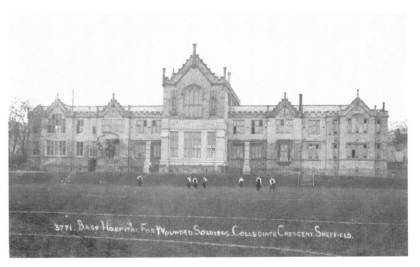

Above left: Just up the road from the main Sheffield University buildings is the Children's Hospital, Weston Park, shown here in the early 1900s. This is one of the leading British hospitals for the treatment of sick children.

Above right: The former school and college site is shown here as a base hospital for wounded soldiers on Collegiate Crescent, Sheffield, in the First World War.

Below right: This picture shows the base hospital for wounded soldiers on Ecclesall Road, Sheffield, 1918. The site and buildings are now the location for Sheffield Hallam University's Collegiate Campus.

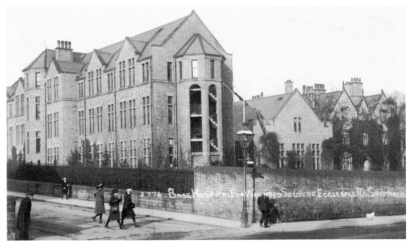

City General Hospital, Herries Road, Sheffield. (110)

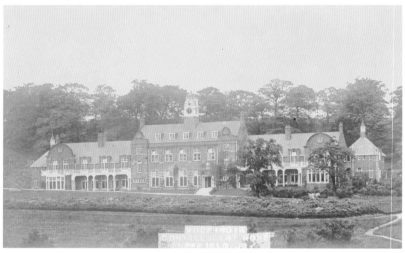

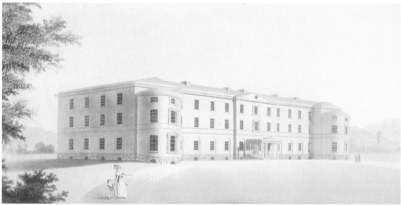

Above left: This very sombre picture shows the City General Hospital, Herries Road, Sheffield, in the 1930s. The site has since grown to become the Northern General Hospital.

Above right: Several Sheffield hospitals, mostly either isolation wards or convalescent homes, were located away from the city centre. Woofindin Convalescent Home, Fulwood, Sheffield, is one such example and is pictured here in the early 1900s.

Below left: Sheffield Royal Infirmary was painted in 1804 by I. Rawsthorne and is shown standing in spacious green parkland. In its latter days, the hospital was in somewhat less salubrious environs.

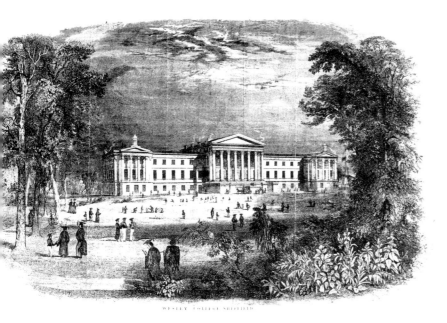

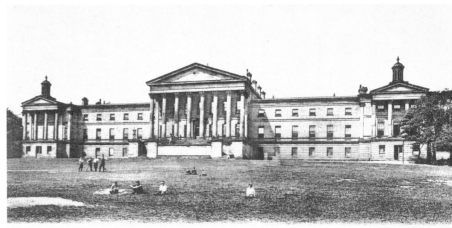

Wesley College, Sheffield

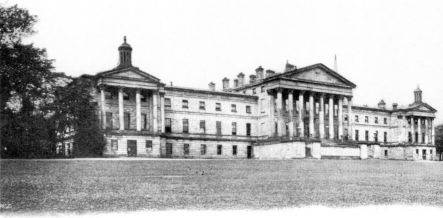

WESLEYAN COLLEGE, SHEFFIELD.

Above left: This Victorian print shows Wesley College, Sheffield, in the 1800s in a suitably studious and sylvan setting. Boys and masters recreate in the grounds and a carriage arrives at the foot of the headmaster's steps.

Above right: Wesley College, now King Edward VII School, is shown in the early 1900s with boys playing cricket on the 'close'.

Below right: This view shows the impressive building of the Wesleyan College, which became King Edward VII Grammar School and is now the upper-school campus for King Edward VII Comprehensive School. Here it is pictured in the early 1900s.

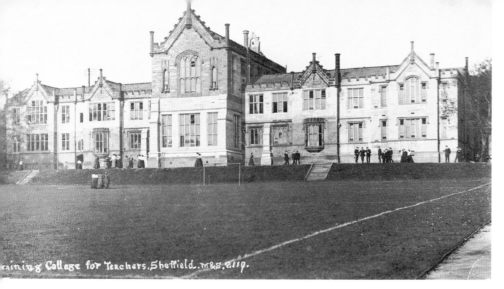

The teacher training college on Collegiate Crescent is pictured in the 1920s and went on to become Sheffield Polytechnic and then Sheffield Hallam University.

One of the rivals to King Edward VII School was High Storrs Secondary (later Grammar) School, off Ringinglow Road, purpose built in the 1920s. Now recently refurbished, it has become High Storrs Comprehensive.

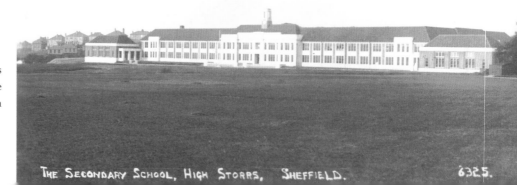

TRANSPORT IN AND AROUND THE CITY

As Sheffield grew and transport systems evolved and changed, the tentacles of the road network reached out from the heart of the city to its numerous satellite villages, hamlets, and townships. Horse and cart or carriage gave way to tram, bus and motorcar. Roads were supplemented for industry by canals and then rail, and even for a short while, air. The developing roads extended along the river valleys and crossed the high ground between to join the otherwise disparate and separate communities. Many roads were almost impassable as surfaces were poor and maintenance minimal. By the 1700s and 1800s, toll-charging turnpikes were the order of the day and new, often straight roads were cut across the landscape. Surfacing improved, with limestone chippings for macadam surfaces, and these were followed by tarmacadam. By the 1960s, the motorways arrived and by the 1990s, for a short time only, Sheffield boasted its own airport.

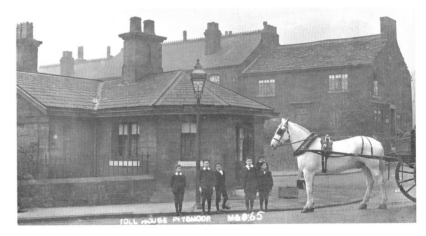

An earlier innovation in regional transport was the development of toll roads to try to improve the dire conditions of the unsurfaced and poorly maintained tracks, a scenario that may sound familiar in 2013. Here we see the toll house in Edwardian Pitsmoor, with smartly dressed schoolboys at the roadside.

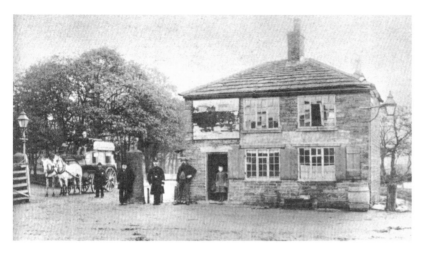

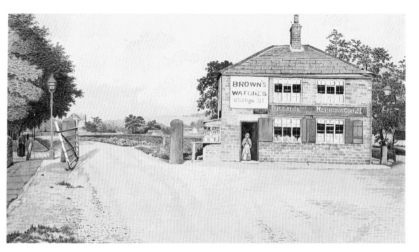

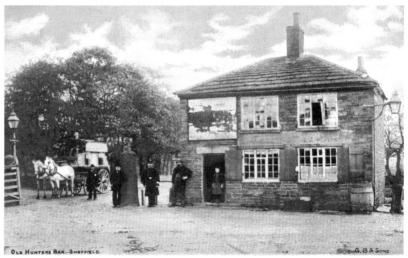

Above left: One of the more widely known toll bars was at Hunter's Bar, shown here in 1884.

Above right: S. Bell painted Hunter's Bar sometime around 1870.

Below right: Hunter's Bar Toll Gate is pictured in the early 1900s with carriage, a man, presumably the toll house keeper, and a policeman standing rigidly to attention.

Opposite: Transport has always been important in Sheffield's development, but the airport was originally contentious and in the end, short-lived. Controversy has marked the ending of commercial flights, and the small airport, while it lasted, was easy and handy to use. This shows a flight from Sheffield Airport at Tinsley in the 1990s.

Abbeydale Road Beauchief

River Don.

Above left: Abbeydale Road is shown at Beauchief, perhaps in the early 1900s, but the image is unrecognisable today. The rubble piles to the side of the road could be material for resurfacing and there might be a road off the main road to the right. A typical gas lamp seems to be the only roadside illumination. This is one of several arterial roads which run out to the west from Sheffield city centre.

Above right: It is easy to forget the role of the canals in our early industry, and they were especially significant from the 1700s into the 1800s. Coal and other materials were carried by barge well into the 1900s. The picture here is of a typical barge transporting goods along the River Don, where navigable, or along the Tinsley Canal, in the early 1900s.

Below left: This remarkable image of Chesterfield Road, Woodseats, was posted in 1945 but is probably an earlier scene. The tram and tramlines, the stone walls, and the trees right by the roadside contrast with the area today. I think this may show the road close to the present-day Homebase site in Woodside Quarry. The site was originally Woodside Brick Co. and there are many local place names indicating ancient woodland on the land.

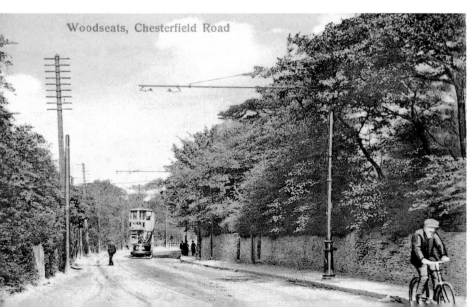

Woodseats, Chesterfield Road

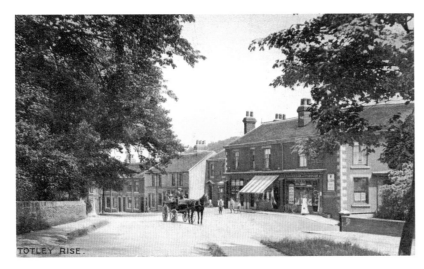

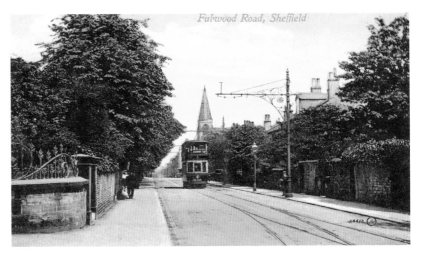

Above left: Beyond Abbeydale and Beauchief we see Totley Rise, with horse and carriage, a lady and a bicycle, and small boys with caps. The new road has cut a swathe through this scene but the shops are still there.

Above right: The picture here shows Fulwood Road in 1905, and in a very verdant and still rural landscape setting. The location might still be identifiable from the walls and gate if they survive and from the slight hill. The mature oak trees are quite striking.

Below right: Closer to town and Broomhill, the scene of Fulwood Road and the tram in the early 1900s is more urban. This situation is still clearly recognisable today.

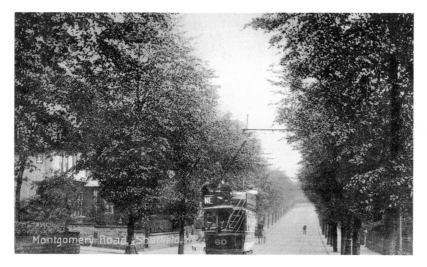

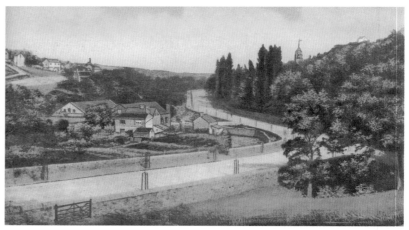

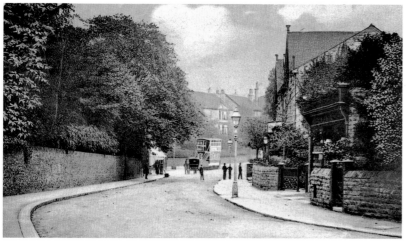

Above left: Montgomery Road in Nether Edge is pictured around 1905, as a tree-lined avenue with the Number 60 tram and a pony and trap.

Above right: Rivelin New Road, with mill buildings in the mid-ground and Walkley and Lower Stannnington in the distance, is pictured in this artistic image of the area. Heading west out of north Sheffield, this view shows the young roadside trees and the gradually spreading suburbs.

Below left: This image shows the tram terminus at Nether Edge in the early 1900s. While there have been changes and the road is wider, this location can still be seen.

Opposite: Fitzalan Square with a single-decker tram, ranks of hansom carriages, people, and a horse and cart. The city centre was a hustle and bustle of men, carriages and horses. Notice the horse with its nosebag of oats. The spilt seed would have fed thousands of house sparrows in the town centre.

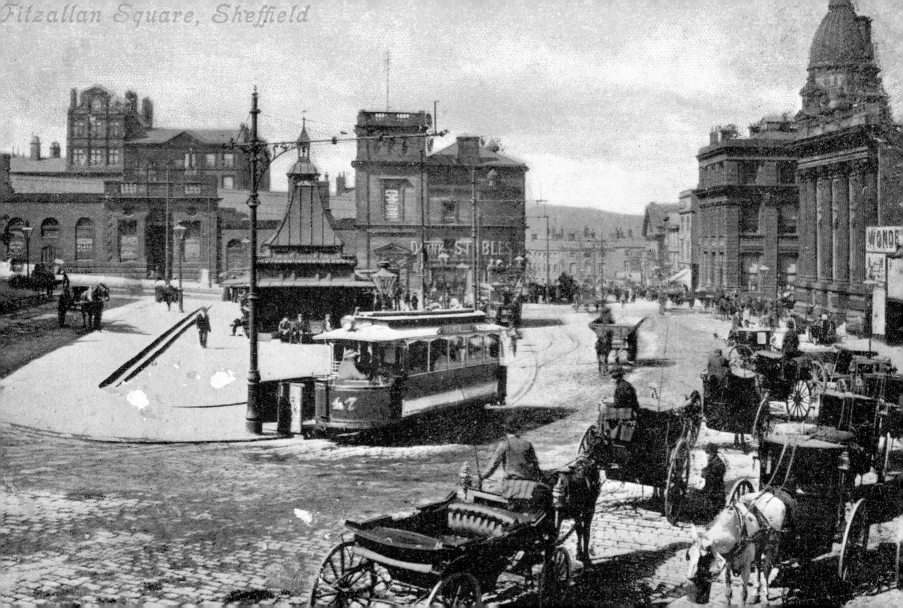

Fitzallan Square, Sheffield

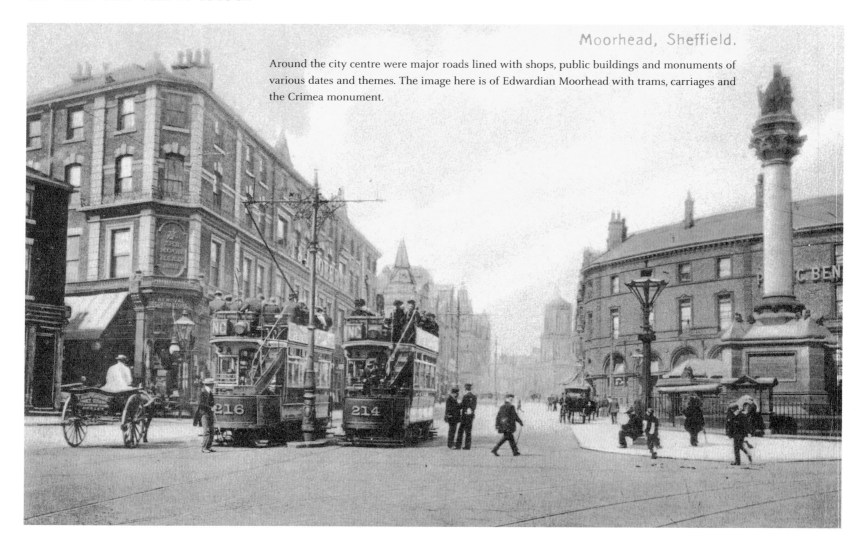

Moorhead, Sheffield.

Around the city centre were major roads lined with shops, public buildings and monuments of various dates and themes. The image here is of Edwardian Moorhead with trams, carriages and the Crimea monument.

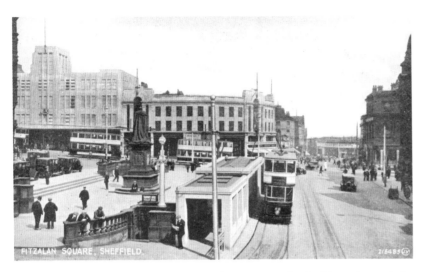

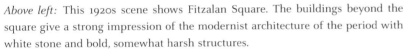

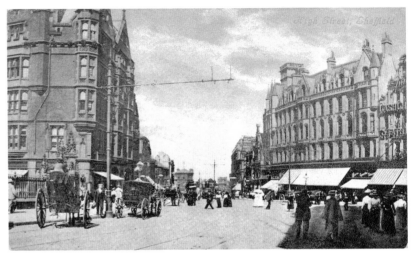

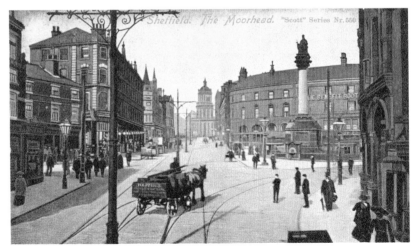

Above left: This 1920s scene shows Fitzalan Square. The buildings beyond the square give a strong impression of the modernist architecture of the period with white stone and bold, somewhat harsh structures.

Above right: At the core of the transport network was the high street, shown here in the early 1900s with carriages and busy shoppers.

Below right: The Moorhead is shown in Edwardian times with horse and cart, tramlines and a distant view of St Paul's Church. The black coats, suits and dresses are noticeable, as are the fine hats sported by both men and women.

Still there today, the Five Arches Railway Viaduct in the Don Valley near Hillsborough is pictured around 1906. Nowadays the open green landscape has become increasingly urban – for many years it was industrial and now it is post-industrial.

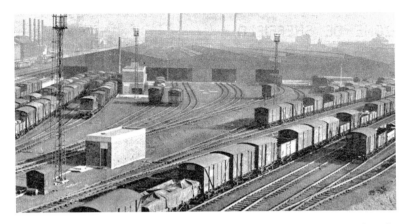

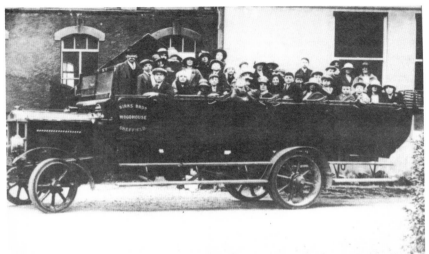

Above left: From the mid-1800s to the 1960s, the railways became hugely significant transport arteries for Sheffield, for both its people and for industrial produce. This French card shows 'the new goods railway station' in Sheffield, and is dated 1966.

Above right: The roads were used for pleasure and leisure as well as for work. The photograph captures Sheffield Birk's Bros charabanc heading out on an excursion from Woodhouse in the 1920s.

Below right: The T. Blundy No. 85 charabanc tour was from Sheffield to Matlock Bath in the 1920s. This and other local destinations were the tourism hotspots of the day. Notice the ladies wrapped in their finery and especially the furs – fashionable insulation against the bitter cold of open-topped transport.

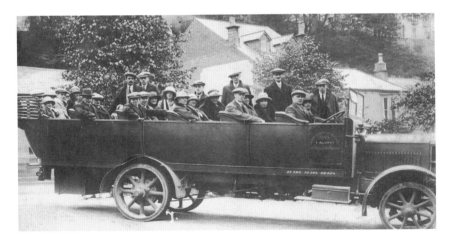

9

SPORTS, THEATRE AND ACTIVITIES

Sheffield boasts the first ever Association football club in the world (Sheffield FC) and the longest-serving professional football ground (Bramall Lane). From the two football grounds to county cricket, the rugby union, the rugby league, ice hockey, basketball and athletics, Sheffield has a long and proud sporting tradition. The city also has a rich tradition in music, theatre and other entertainments. Most of the small music halls and theatres have gone and the once ubiquitous working men's clubs have mostly passed into history. Great theatres and concert venues remain, and the Crucible is globally famous as the home of the World Snooker Championships.

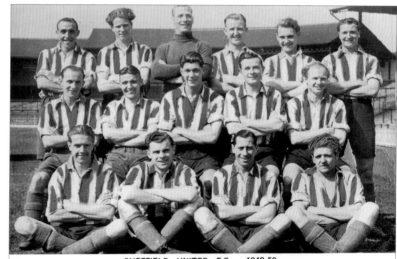

SHEFFIELD UNITED F.C. 1949-50.
Back row, left to right. Furniss, Hitchin, White, Latham, Shaw, Cox.
Centre row, left to right. Thompson, McLaren, Smith, Hagan, Collindridge.
Front row, left to right. Brook, Bailey, Jones, Warhurst.
PRESENTED BY SPORT.

This picture presents Sheffield United Football Club, first team, in 1949–50 with some remarkable hairstyles, including one with apparent dreadlocks. Did they really have hair like that in 1950?

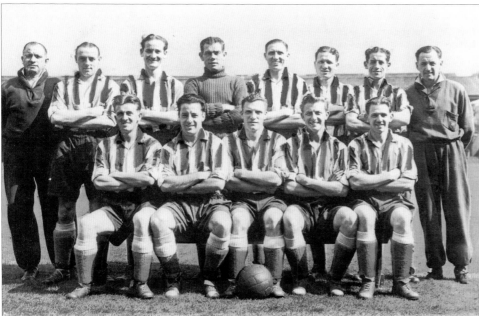

SHEFFIELD WEDNESDAY F.C. 1949-50.

Back row, left to right. S. Powell (Trainer) E. Gannon, V. Kenny, D. McIntosh, F. A. Westlake. E. Packard.
D. F. Whitcomb, W. Knox (Trainer-Coach)
Front row, left to right. Fox, E. Quigley, C. Jordan, R. Froggatt, D. Woodhead.

PRESENTED BY **SPORT**

Above: Sheffield Wednesday Football Club, first team, shown in 1949–1950 on a black-and-white card with the blue stripes and green grass painted in.

Right: Now here we see a typical Sheffield Wednesday star player, in this particular case one from the early 1900s. If only they had a few more like this...

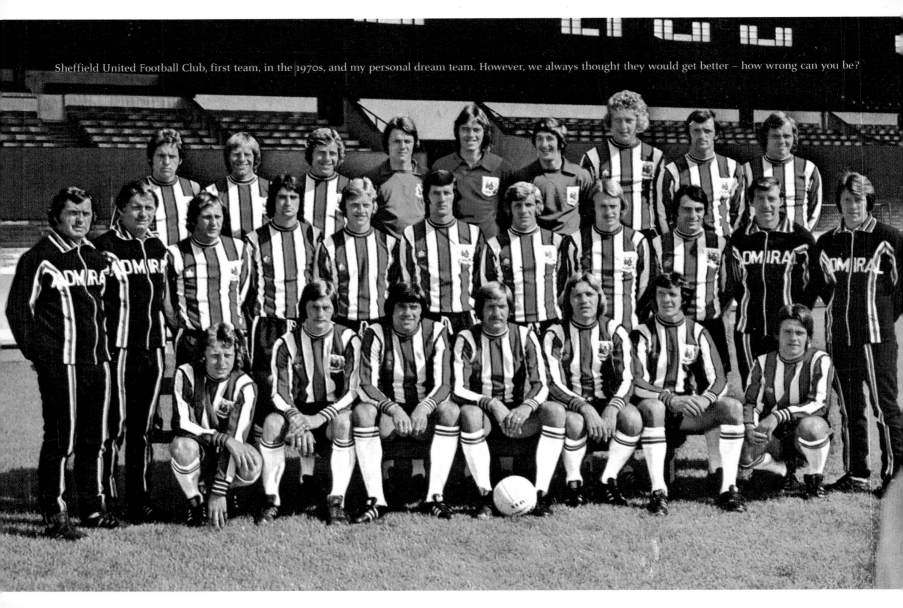

Sheffield United Football Club, first team, in the 1970s, and my personal dream team. However, we always thought they would get better – how wrong can you be?

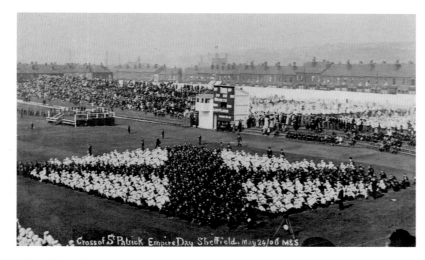

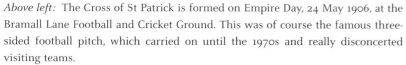

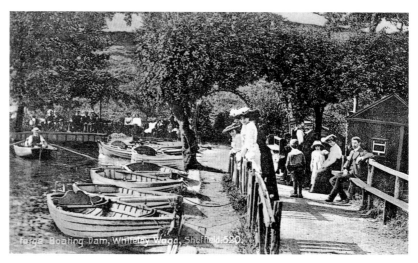

Above left: The Cross of St Patrick is formed on Empire Day, 24 May 1906, at the Bramall Lane Football and Cricket Ground. This was of course the famous three-sided football pitch, which carried on until the 1970s and really disconcerted visiting teams.

Above right: All the local parks boasted boating or bathing ponds and other sporting and leisure facilities. This example is Forge Boating Dam, Whiteley Woods, in 1906.

Below right: This is an example of the typical park bathing facility, in this case, the swimming pool at Longley Park in the 1960s.

Painted by Engolras.

Exhibited at the Salon, Paris.

CLAIRE FORSTER
"THE WOMAN IN THE CASE"
LOUIS MEYER'S COMPANY.

Left: For six nights from Monday 3 April 1911, you could see Claire Forster in *The Woman in the Case* at the Lyceum Theatre, Sheffield.

Above right: Sheffield had many concert halls and theatres; most have now gone. However, Sheffield City Hall was the main concert venue in the 1970s and every big group, from Status Quo to the Beatles, played there. Revamped and modernised, it still hosts a variety of events both large and small.

Below right: The Lyceum was the city's premier theatre until its closure in the 1980s. This picture is of Tom Jones at the Lyceum Theatre for six nights from Monday 11 to Saturday 16 January 1909, with a matinee on the Saturday. The building was restored in the 1990s.

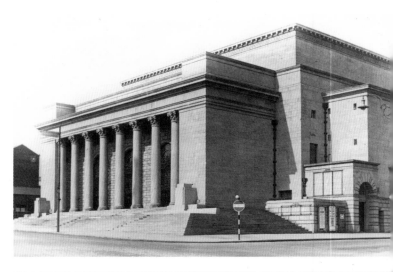

BIBLIOGRAPHY AND SUGGESTED READING

There is a huge literature on the history of Sheffield, of its people and its industries. All of these and more are available in the Local Studies Library.

Barnes, J., *Ruskin in Sheffield* (Sheffield: Sheffield Arts & Museums Department, 1985).

Bostwick, D., *The Great Sheffield Picture Show* (Sheffield: RLP (Sheffield) Ltd, 1989).

Bunker, B., *Portrait of Sheffield* (London: Robert Hale, 1972).

Hey, D., *A History of Sheffield* (Lancaster: Carnegie Publishing Ltd, 1998).

Hey, D., *Historic Hallamshire* (Ashbourne: Landmark Publishing Ltd, 2002).

Hey, D., *Medieval South Yorkshire* (Ashbourne: Landmark Publishing Ltd, 2003).

Jones, M., *Sheffield's Woodland Heritage* (Sheffield: Wildtrack Publishing, 2009).

Orwell, G., *The Road to Wigan Pier* (London: Victor Gollancz, 1937)

Pawson & Brailsford, *Illustrated Guide to Sheffield* (Sheffield: Pawson & Brailsford, 1862).

Smithurst, P., *Sheffield Industrial Museum, Kelham Island: A Guide to Sheffield's Industrial History* (Sheffield: Sheffield City Museum, 1983).

Vickers, J. E., *The Odd, Amusing and Unusual in Sheffield* (Sheffield: J. Edward Vickers, undated).

Vickers, J. E., *The Old & Historical Buildings of Sheffield* (Sheffield: JEV Publications, 1968).

Vickers, J. E., *Old Sheffield: Its Streets, People and Stories* (Sheffield: JEV Publications, 1970).

Vickers, J. E., *The Ancient Suburbs of Sheffield* (Sheffield: JEV Publications, 1971).

Vickers, J. E., *The Unseen, the Unsightly and the Amusing in Sheffield* (Sheffield: The Hallamshire Press, 1997).

Walton, M., *Sheffield: Its Story and Its Achievements* (Sheffield: Sheffield Telegraph & Star Limited, 1948).

ACKNOWLEDGEMENTS AND CREDITS

The pictures here are from my own extensive personal collections of postcards, photographs and antique books, or reprints of old prints and paintings. I want to thank Philip Broomhead, the former director of the then Sheffield City Museums, and the curators of the time, especially the late Janet Peatman (Abbeydale Industrial Hamlet), David Bostwick (City Museum), Janet Barnes (of the Ruskin Gallery) and Peter Smithurst (Kelham Island). They directed me to the remarkable collections of paintings and prints at the time held in the City Museums collections. They raised my awareness of these as a source for research and provided access to prints and other materials.

 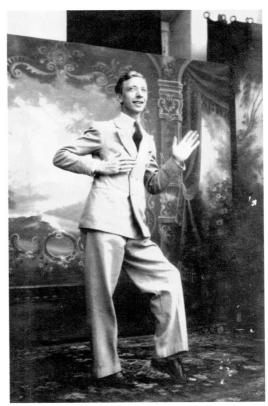

Above left: Serpentino the contortionist is pictured at the Empire Theatre, Sheffield, on 30 June 1934.

Above middle: Performer Olga May at one of the Sheffield theatres, perhaps the Empire, and in a rather risqué pose, in 1933, from a photograph rescued from a local boarding house used by performers.

Above right: Among the acts servicing the numerous theatres would be stand-up comedians combining a song, a dance, some jokes and a silly walk. This is a picture of an unknown performer at a Sheffield theatre in the 1930s, and a lodger at Mrs Shearstones's boarding house.

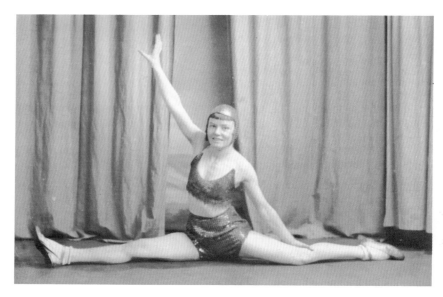

Above: The theatres offered a variety of entertainments, and of course newsreels. This photograph shows Lemona the contortionist at the Empire Theatre, Sheffield, on 30 June 1934. Others presented burlesque shows such as *Strip Strip Hurray.*

Right: Every district of the city had its own theatre, and Edwardian actress Pearl White appeared at the Heeley Palace from 1 April, Easter Monday, running for twenty weeks in *The Fatal Ring,* no date given. The building still stood until its demolition in the late 1970s. The Ponsford's extension now occupies the site, but at least Pearl got a good run.

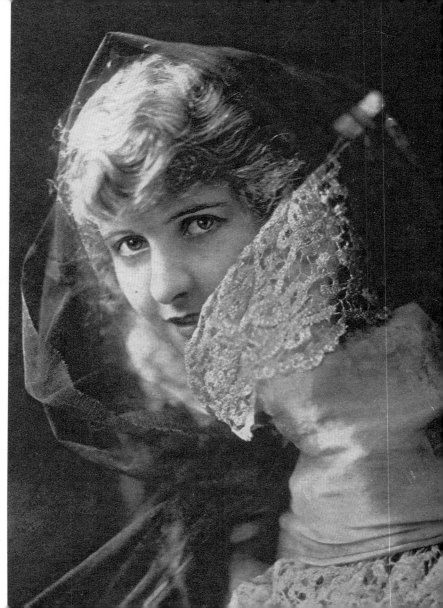